David Wild

jazzpaths

an American photomemento

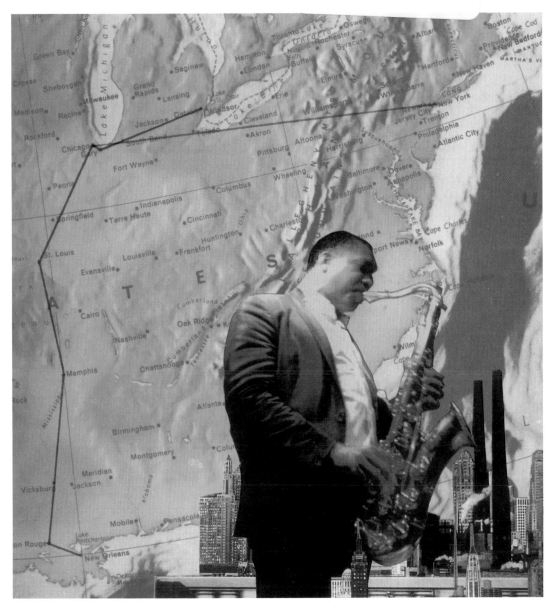

Hyphen Press . London

Published by Hyphen Press, London, in 2011
Text, photographs, collages copyright © David Wild 2011

The book was designed in London by David Wild and Robin Kinross,
who set the type and made the pages in Adobe InDesign. The text was
set in the typeface Century Schoolbook with Franklin Gothic (designed
by Morris Fuller Benton: ATF / Bitstream). The book was printed in
Belgium by Die Keure, Bruges

ISBN 978–0–907259–45–9

www.hyphenpress.co.uk

Acknowledgements:
Some photographs have been reproduced in earlier publications, including
Paul Oliver's *The story of the blues,* and in John Jeremy's film *Jazz is our
religion*. Thanks to Christopher Phillips for rephotographing the collages
and photomontages, to Manou Shama-Levy and Richard Hollis for com-
ments on the book in progress

Previous pages: Afro-American photomontage | Jazzpaths

Contents

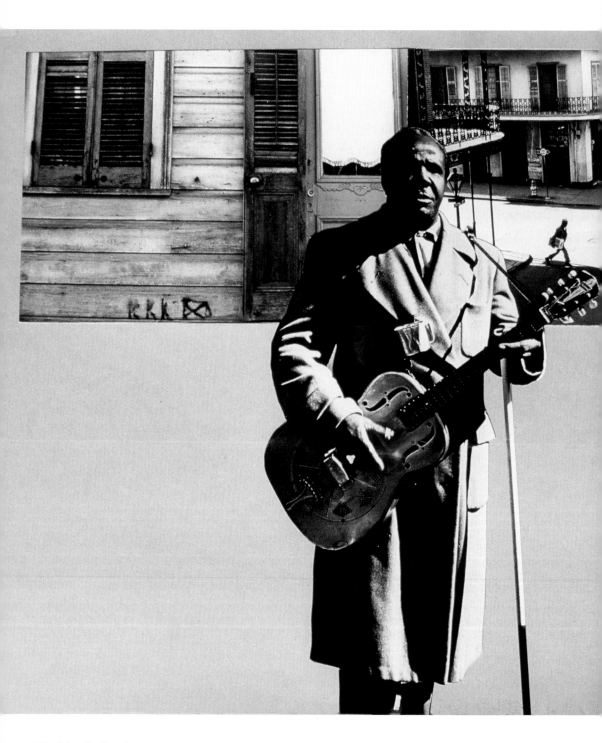

Blind Arvella Gray (montage)

Introduction

The traditional history of jazz, that extraordinary by-product of the slave trade and the confederate plantation system – an economy that made possible the purchase of Louisiana in its entirety from the French in 1803 – begins in the humid and libidinous climate of New Orleans. Cosmopolitan seaport at the mouth of the Mississippi, the Storyville area became the brothel of Louisiana, where the hierarchy of class and colour went in step with the society at large. With the government closure of this area in 1917, the music that had been a background entertainment moved upriver first to St Louis – where a certain W. C. Handy would claim authorship of the blues – before passing through Kansas and Chicago, to arrive in 1938 at the prestigious Carnegie Hall in New York for the famous Benny Goodman concert. Crowned the 'King of Swing', his popular orchestra had lost the battle of the bands with Chick Webb at the Savoy in Harlem, while the rightful pretender to that throne was surely Count Basie. Nevertheless, with arrangements by Fletcher Henderson, the Carnegie Hall concert remains a defining moment.

What had begun as a social music within the African-American community, soon entered the mainstream of American popular music: its rhythm and improvisation, based on the unique singing quality of the self-taught ex-slaves, brought new life to hackneyed ballads. After Louis Armstrong's version of 'Dinah' in the 1920, popular music would never be the same.

The rapid development of this music, from the resignation of the so-called authentic blues, to the affirmation of bebop, or as an accompaniment for local local criminal enterprises, to a cultural export by the US State Department, is remarkable. The career of Louis Armstrong, the first jazz genius, from delinquent waif to 'Ambassador Satch', mirrored this. The advent of radio and recording equipment, feeding a growing consumer market, surely played a part: but the worldwide appeal of jazz stands as a testament to the creativity of the original musicians, who with few exceptions were exploited along the way.

My two years in America reversed that earlier itinerary, starting instead in New York.

Actual size

Radio City

My first encounter with jazz was probably being brought along to a Harry James Orchestra concert at the Radio City Music Hall in New York. 'Two hours in the washed, ionized, ozoned, ultrasolarized air are worth a week in the country', the publicity claimed. It must have been a matinee, for, as the comedian Bill Cosby recalled, 'these were the days before babysitters'. I have no recollection of this, unsurprisingly, when set against the excitements of this city for a four-year-old: atop the Empire State Building, or at a rodeo in Madison Square Garden. The concert did, on the other hand, put my mother off big-band jazz and 'squealing trumpets' for life. We came to be in America during the War, due to my father's posting with the Royal Navy. American entry into World War II meant even closer collaboration on the vital Atlantic convoys, and we had set sail to join him on the Queen Mary: pride of the Cunard Line, she could outrun the Nazi U-boats. Nevertheless, an alert saw us diverted to Boston and we were deprived of that celebrated harbour view. A subsequent stay in Asbury Park, New Jersey, was less memorable, save for the special sound of my first bicycle's tyres on the timber planks of the seafront boardwalk. Two years later we returned to England on an aircraft carrier, part of a massive convoy ready for D-Day.

Our new home in Lee-on-Solent was so close to the airfield that from the garden I could see the pilots' faces as they brought planes ashore. Once one clipped a tree top at the end of the road, crashing in a ball of flame, just beyond the last house. A special visit was made to London, where we stayed with grandparents – some nights spent under the stairwell, supposedly the safest place, listening out for the sound of the V1 flying bombs, the dreaded 'doodlebugs'.

Dressed in a miniature US uniform, complete with cardboard Sam Browne belt, I remember going to Buckingham Palace with my mother, to see my father decorated by the King.

It was always on the cards that I would be drawn back to America after such strong impressions, but some twenty years passed before the opportunity arose. We saw out the 1940s with another overseas posting, to Trincomalee in

Radio City Music Hall, N. Y. C.

One of the tiny postcards from this surviving war-time memento

This little girl, a neighbour in America, was to call for me to go on a toboggan outing; instead she went ahead early and told everyone I couldn't come

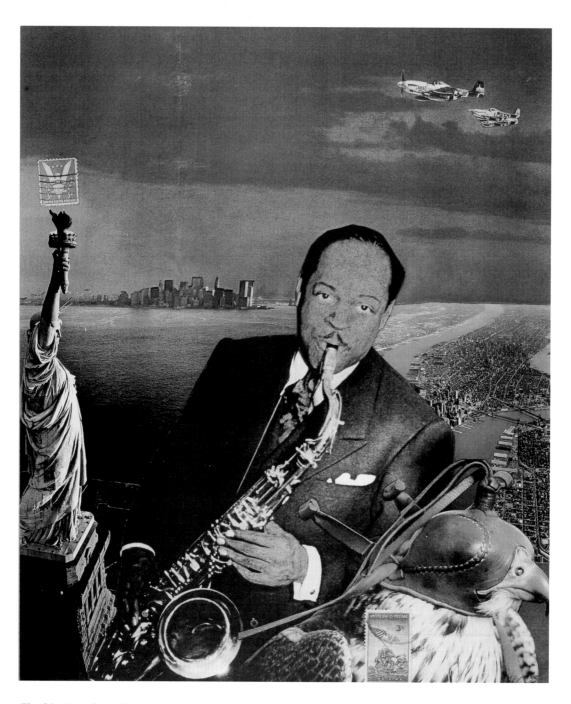

'Hawk's victory boogie'

Ceylon, a country of wondrous sights and the site of memorable adventures. A solitary figure in a sweltering classroom within the naval dockyard, I sat the obligatory eleven-plus examination that would decide my future school.

Ceylon, 1948

Back at home again, the influence of all things American continued. Every month the *National Geographic*, in its distinctive yellow jacket, would drop through the letter box, while every week we took our seats in the local cinema to watch Hollywood movies: Technicolor romances or black-and-white 'film noir'. Cheaply shot without elaborate studio lighting, these second features often had a dramatic immediacy – the result of less interference from studio bosses. An excellent example was *D.O.A.*: a story of slow-acting but fatal poison, and mistaken identity, it also contained a terrific jazz club sequence. The cinema formed part of a curved, modern complex, including a restaurant, ballroom tower and pier – this partly demolished to prevent enemy use. Next door was an amusement arcade and juke box, where I would listen to Earl Bostic's raucous take on the popular ballad 'Flamingo'. This was the one place where we could escape the stark choice between tennis club, youth club, or boy scouts – where I got as far as second class, with a scout master I could now confidently describe as fascist.

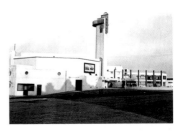

Lee Tower, Lee-on-Solent, built in 1935

American comics and science fiction magazines were traded among us, while jazz and popular music conquered the airwaves, thanks to the American Forces network, the Voice of America, or Radio Free Europe. What was essentially an African-American subculture was being exported as an example of democracy while discrimination remained at home. This was a cause of anger among the new generation of modern jazz musicians, which would surface in the music of the 1960s. Thanks to the postwar Labour government we were getting free school milk and an excellent education, albeit from an odd collection of teachers: some of them had been in the War, but many looked unfit for service – including the Latin master who never turned his back, writing on the blackboard while facing us and declaring that it would have been better if Hitler had won.

The 1950s may have been boom-time in America, but not for us. The loan that Churchill had begged from Truman, our NATO ally, would not be fully repaid until the next century. Our world remained drab and mediocre,

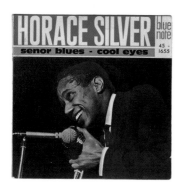

'Señor blues' was the signature tune for one of the favourite jazz stations

I tried this sheet music on my mother, a keen pianist, but she struggled with the rhythm

compared with the image of America. The attempt to lift our spirits with the Festival of Britain was gone, while the threat of nuclear annihilation remained.

Still counting the pennies, it was the smaller 45 rpm 'extended plays' that formed the basis of most collections and record sessions. Surfing the airwaves revealed such delights as Frank and Daniel of 'Pour ceux qui aiment le jazz' – their description of an orchestral backing to Erroll Garner's piano as 'absolument grotesque' was never forgotten. His *Concert by the sea* LP was even enjoyed by my mother.

The mid-1950s saw some jazz in Technicolor for the first time, spurred on by the success of *The Glenn Miller story* – which I sat through more than once just for the jam session with Louis Armstrong and Gene Krupa. *The Benny Goodman story* followed close behind: an inferior biopic, it nevertheless brought together the original musicians of the quartet, including Gene Krupa, whose rousing drumming brought life to the concert finale. Benny Goodman himself also appeared as a music professor in the film *A song is born*, memorable only for some jazz interludes. The same year (1955) saw the release, in colour and widescreen, of *Pete Kelly's blues*, a surprisingly authentic tale of a bandleader under the thumb of a gangster, played by Edmond O'Brien, brutally abusing his mistress – the singer Peggy Lee – in the process. Opening with a traditional funeral in New Orleans, it moves into the Prohibition era of bootleggers and nightclubs that allowed organized crime to gain a foothold in show business, but sadly the music remains Dixieland, in spite of a cameo performance by Ella Fitzgerald as the singing owner of a gin joint. In a bizarre twist, Edmond O'Brien reprised the role of a gangster with a singer girlfriend in *The girl can't help it* – this time as farce, complete with Little Richard and other rock'n'rollers.

A glamourized delinquency was even being exported by Hollywood – Marlon Brando in *The wild one*, James Dean in *Rebel without a cause*, and *The blackboard jungle* with its opening rock'n'roll music by Bill Haley: another white, marketable version of black rhythm and blues. The contrast with our repressed existence – my father had warned that what was termed 'self abuse' would lead to homosexuality – could be seen as another reason for the

restless among us to identify with the jazz musicians' blend of exuberance and melancholy. We were not descended from slaves nor subject to racial discrimination, yet everything about our *Boys' Own* school, from corporal punishment by staff and prefects, to the uniform that marked us out as we went back and forth laden with homework, suggested preparation for some form of indentured servitude. One of my reports referred to attitude 'both in and out of school', which prompted the reminder that it was out of school that our kindly Divinity master was arrested, in woman's clothing, while conversing with sailors.

Now in the sixth form, and chafing at the bit, we tried to engage our music master in a discussion about jazz. Its appeal was lost on him. 'There's all the rhythm you could want in Beethoven', he insisted, while trying to correct our Hampshire accents in time for a performance of Handel's *Messiah*. Our fictional counterparts in *The blackboard jungle*, meanwhile, repaid their teacher's attempt to interest them in jazz by smashing his precious record collection.

With my purgatory in Science Sixth over, I found a labouring job on a site just down the road from the school, opposite a brand-new student hostel designed by Frank Guy and Jack Ogden, who would become my design tutors at the Portsmouth School of Architecture. I had originally planned to take up the place offered at the Architectural Association School, after completing the two years of National Service in the RAF. With only one 'A level' pass, a grant was out of the question. Staying at home, provided I got a job in the holidays, meant that my parents could afford the then minimal fees. I enrolled straight away; what seemed failure turned out to be a stroke of luck as, by the time I received my diploma, National Service was over.

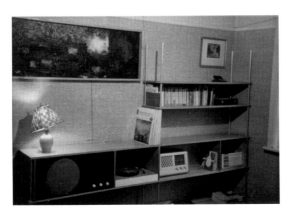

Home-made hi-fi, analogue radio, and shelving in a room of my own. The stamp-covered lampshade was made by my father on our return from America

Pompey chimes

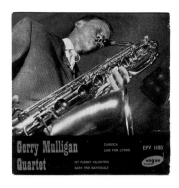

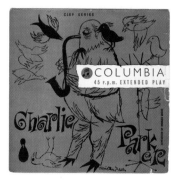

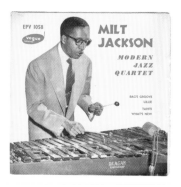

45s from the 50s

The atmosphere at the architecture school, part of the Southern College of Art, was liberating. Three of us took over the running of the art students' association, using funds to set up college dances with local jazzmen, records for the common room, and coach trips to London. These dances became a little too popular with the public: this culminated in the wrecking of Kimbells Ballroom. We went for the American 'college boy' look – I had an Ivy League jacket, worn until threadbare – rather than the duffle coats of the 'trad jazz' fans.

The cool jazz of the West Coast was now popular with us students, both here and in the USA: Dave Brubeck, Gerry Mulligan especially. An appreciation of the brilliant intricacy of bebop would come later. I did however have a couple of favourites – Charlie Parker's later version of 'Lover man', with John Lewis on piano, and Dizzy Gillespie's 'The champ'.

It's easy to see, now, how our few records barely touched the range of jazz that was being made in this prolific period, from *Birth of the cool* to *Hard bop*, or the music of Sun Ra's extraordinary 'Arkestra' with the tenor player John Gilmore, said to have influenced John Coltrane. The record that stood out for me at that time was the Modern Jazz Quartet's *Django*: fortunately available on a 45 rpm EP. Recorded in 1954 as a tribute to the memory of Django Reinhardt, the phenomenal gypsy guitarist and Stéphane Grappelli's partner in the Quintette du Hot Club de France, it remains a perfect blend of composition and improvisation. That this group could have emerged from the ebullience of the Dizzy Gillespie Big Band was something of a surprise. A film of the band from this period has Milt Jackson playing vibes behind an 'exotic dancer'. Dizzy's clowning must have been irksome for the more serious John Lewis, whose presentation of the MJQ, as they became known, could be seen as a rebuttal of this. I was prompted to write to Kingsley Amis, then jazz critic for the *Daily Telegraph* (my father, no longer on the lower deck, had by now switched from the *Daily Express*). It's interesting to com-

14

Changing styles of letter writing

pare his reply with the one I would later receive from Benny
Green, while I was in America. Having previously dealt
with the MJQ, he was now issuing a challenge to 'the Cole-
man Brigade'. This reminded me of the comment of 'best of
luck, mate' when I asked for the Ornette Coleman *Change
of the century* album in Dobell's Jazz Record Shop, long
before travelling to America to see and hear such music.

This period also saw the emergence of the vibrant Free
Cinema movement with a short film directed by the young
Tony Richardson. Shot without dialogue, the soundtrack
just the 'Trad' jazz that is played on-screen, and titled
Momma don't allow after one of the songs, it followed a
group of working youngsters as they finish their day, for
a session with the Chris Barber band at the Fishmongers
Arms in North London. The fantastic exuberance of one
girl, seen earlier cleaning railway carriages, as she jives in
double time, contrasts with the squirmingly self-conscious
toffs who turn up later in a Rolls Royce. Luckily they don't
stay too long. Unlike the rest of the kids, with their original
style of dress – the Teddy Boy look – and hairstyles – quiff
and D.A. – the toffs are dressed exactly like their parents.
No need for revolt here. It was an odd thing at this time
of battle between Trad and modern jazz that the toffs
preferred the old: Old Etonian Humphrey Lyttleton lead-
ing the revivalists. If his surprising hit record 'Bad penny

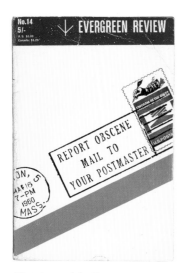

This issue of the Evergreen Review, *with its clever cover, contained a brilliant review by Jerry Tallmer of* Jazz on a summer's day

blues' had been followed by 'Silver spoon shuffle' I would have been more impressed. One member of the Barber band, Lonnie Donegan, launched the 'skiffle' craze with a hit version of 'Rock Island Line'. The great thing about this homemade music, with its primitive instrumentation, was its 'have a go' quality.

Filmed performances of jazz musicians had been pioneered in the USA during the War, with three-minute 'soundies', some of these now available on DVD compilations. There were also a few notable short films, including *Jazz dance* (1954) filmed at Central Plaza Dance Hall in New York, comparable with *Momma don't allow*. This would often be shown in jazz clubs, as well as *Jammin' the blues*, with Lester Young, and *After hours*, with Coleman Hawkins at his peak. A film that stood out above all these was the later *Jazz on a summer's day* filmed by Bert Stern at and around the 1958 Newport Jazz Festival. It remains, for me, a vision of some sort of paradise, and was a major influence in my desire to return to the USA. Chico Hamilton – whose intense mallet solo on drums was such a memorable part of this film's night-time sequence – had also provided the music for a far darker look at the night-club world. Titled *The sweet smell of success* and shot almost entirely after dark by James Wong Howe, it cast Burt Lancaster and Tony Curtis against type, as two of the most loathsome characters ever to appear on screen. Their acting was a revelation. The jazz scene in this and other American films took place in nightclubs run by gangsters; our provincial venues were mainly pubs, although some dance bands would also include a few jazz standards. There had been a visit by the Stan Kenton Orchestra to the Savoy Ballroom in Southsea, when it was said that they could be heard in the Isle of Wight.

With money earned in the holidays at a variety of jobs, including an enjoyable summer with Billy Manning's Southsea Fairground, as well as making models for my tutors, I could afford to travel up to London for the Modern Jazz Quartet at the Festival Hall. More local events included Dave Brubeck, in a double bill with our own Jazz Couriers led by Ronnie Scott and Tubby Hayes, in Bournemouth, and various American packages at the Gaumont Cinema

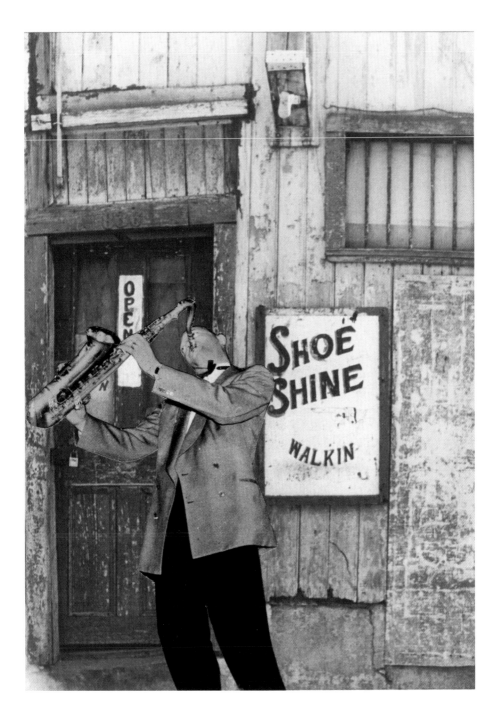

Ralph Ellison, author of the great
Harlem novel Invisible man, said
he first heard Lester Young jam-
ming in a shine chair. 'Shoe shine
boy' was Lester's first recorded solo
with Count Basie

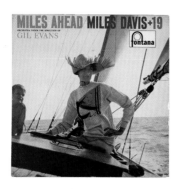

This odd, but beautiful cover was said to have angered Miles for its portrait of a white woman. Coming soon after his affair with two Parisiennes, his reaction seemed a tad hypocritical

in Southampton. It was here that I first saw the Duke Ellington Orchestra, with tenor saxophonist Paul Gonsalves attempting to recreate the barnstorming solo that set the crowd alight at the 1956 Newport Jazz Festival.

The success of my first year at college helped to put the traumatic failure at school into perspective. A portfolio award provided for travel abroad, while a sketch club prize was enough to buy the Miles Davis LP *Miles ahead*, a landmark recording, combining him with the best studio musicians in arrangements by Gil Evans. My girlfriend of that time was soon humming the more wistful numbers, as she prepared to drop me: a member of the snooty local tennis club and a determined virgin, it was a wonder I had lasted so long. The last straw for her was probably being dragged into a sleazy cinema to see *Sait-on jamais*, quite unexpectedly showing in a double bill with *Atilla the Hun*, as we arrived on a day trip to London. This curious, beautiful-looking film with an all-star cast, directed by Roger Vadim, featured a soundtrack by the Modern Jazz Quartet. Another French director, Louis Malle, brought Miles Davis in to record the music for *Lift to the scaffold* with a group of top French musicians. Mostly improvised while watching a studio projection of the rough cut, it was released on one side of an LP. The other side was made up of three perfect ballad performances by the sextet that went on to record the superb *Kind of blue* album. It was while playing with this group on his return from Paris, where he had been treated like a hero, that Miles was beaten up by a New York cop as he refused to move on from a cigarette break outside the club.

This last year at home was a happy one: a serious relationship was developing with Heinke, a German au pair and jazz fan, whom I had met on her day at college. From my first sight of her striking presence, across the Guildhall Square, I had determined to avoid the disasters that had been my first attempts at courtship. My last year tutor, who knew that I planned to finish the course at the Architectural Association, joked that I would be able to marry a debutante and set up in private practice.

Heinke with a Salut les copains *t-shirt*

London

A leaf from a scrapbook of the period

I did miss the art school atmosphere of Portsmouth, and Heinke, who had returned to Hamburg, but here I was just a step away from Charing Cross Road, with Dobell's Jazz Record Shop and Better Books: a great little shop where I bought *On the road*, copies of *Evergreen Review*, Lawrence Ferlinghetti's *A Coney Island of the mind*, and Allen Ginsburg's *Howl*. The so-called 'Beat generation' had arrived; somehow what was in fact a form of protest against conservative America came across as another reason to want to be there.

My arrival in London coincided with the opening of Ronnie Scott's first club, in Gerrard Street. I have a slightly hazy memory of uncomfortable, possibly folding, seats. The club and its later replacement would become the best place to hear visiting players.

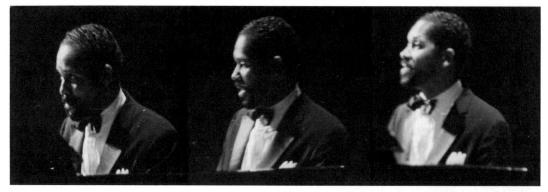

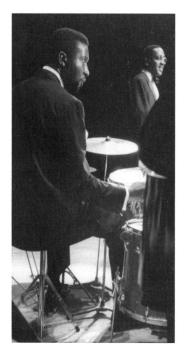

A portrait of John Lewis at the piano was my first published photo – in the Architectural Association Journal. There had been a photographic competition judged by Antony Armstrong-Jones and Michael Peto

Connie Kay and Milt Jackson of the MJQ

The MJQ had returned to the Festival Hall, and from my seat on the stage (the cheap seats behind the musicians) I attempted to take some photos with a Kodak Retinette, a twenty-first birthday gift from my parents. The unusual viewpoint worked quite well for the pianist, so I enlarged John Lewis's face to give a triple portrait, using the school darkroom.

Some years later it was in a similar seat, at the front of the stage, that Thelonious Monk, leaving the piano for his customary dance, asked me for a light. 'I don't think you're allowed to smoke in here' was my feeble reply.

I now had a few long-playing albums. Sadly four of these were already memorial albums: Charlie Parker, first, complete with signed photograph, then Clifford Brown, Lester Young, and Billie Holiday. Peerless performers all: no one played or lived faster than Parker, no one played more lyrically than Brownie, and the combination of Lester and Lady Day – a musical love-match. Such records, however, took the chill off my first smoggy winter in London, with just a paraffin heater for warmth.

The year passed quickly enough, and included a visit to Hamburg, where I bought the Coltrane album, *My favorite things*. After a brief visit from Heinke, when it became apparent that a work permit would not be granted, we decided to marry. After an inauspicious Register Office ceremony, we set off for a few days in Paris, before the new term started. The first delay came with my forgetting the traveller's cheques, the second when a dog got on the tube line at St John's Wood. As soon as we arrived in Paris, I got food poisoning. Staggering back for the new term, pale and drawn, I was asked what I had got up to in the holidays.

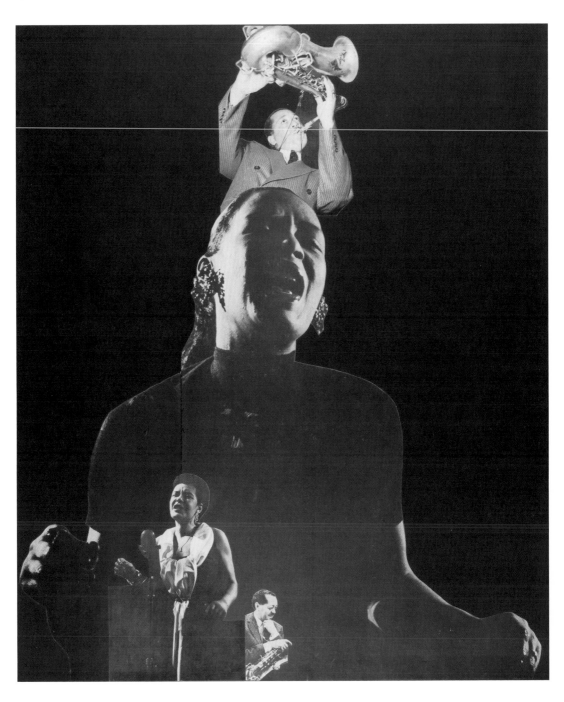

'I'll never be the same': Pres and
Lady Day

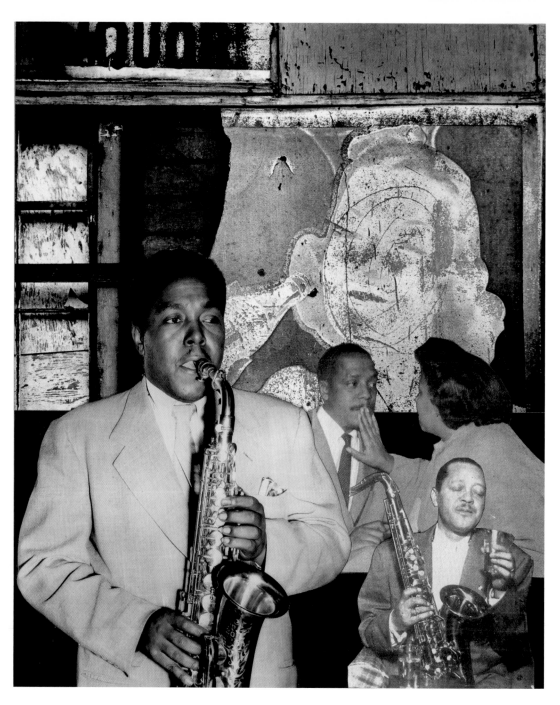

The paths of excess – Bird, Bud, and Pres

We already had a one-room flat in Belsize Park, on the first floor of the house in which the singer Heather Harper lived. We would sometimes even get complimentary concert tickets, and once caught sight of Otto Klemperer as he was helped up the stairs.

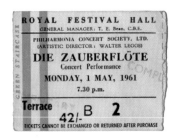

A particularly memorable concert with Heather Harper

The 1960s had just started. We had been informed by the Prime Minister – soon to be a figure of fun with the satirists – that 'we had never had it so good'. This was certainly the case with the cinemas showing foreign-language films – a welcome change from the domination of Hollywood. The Academy Cinema in Oxford Street was a favourite. I had already seen Satyajit Ray's *Pather panchali* here, with the wonderful music of Ravi Shankar, which had a great influence of John Coltrane. There was the French New Wave, Antonioni, Fellini and Visconti from Italy, Andrzej Wajda's Polish trilogy, and Ingmar Bergman from Sweden. Roger Vadim used jazz once again for his modern take on *Les liasons dangereuses*: performed by Thelonious Monk and Art Blakey's Jazz Messengers. Back in the USA, John Lewis provided a superb score for the film *Odds against tomorrow*, and an American New Wave appeared with John Cassavetes's *Shadows*, with music by Charles Mingus.

The Musicians' Union agreement restricting the employment of Americans was not relaxed until 1961, when Zoot Sims came for a four-week residency at Ronnie Scotts. In that year also there was a chance to hear live jazz with the Freddy Redd Quartet and Jackie McLean in Jack Gelber's *The connection*, which ran for a very short time at the Duke of York's Theatre in the West End. A sort of beat version of *Waiting for Godot*, it featured a group of junkies waiting for a fix. When the main character, Leach, got his – very realistically – the woman in front of us fainted.

Times got harder as Heinke became pregnant and her income was lost, not to mention her freedom. My County Major Award was not enough to support a family. Our son, Mark, was born just before the final year – and (in November 1961) John Coltrane arrived in London with Eric Dolphy, to baffle many of the audience. That I could have missed this opportunity to hear them play just wasn't important at that time. Thankfully, there are the complete Village Vanguard recordings from that year.

Mark in a cot made in the AA workshop

Bob Maxwell, our final year master, seeing me turn up at the diploma show with young Mark in a pushchair, offered his compliments and recommended me to the firm of Lyons, Israel & Ellis. Concentrating on schools, hospitals, and social housing, they were an architectural arm of the welfare state. I took a job there.

The flat in Belsize Park was no longer suitable. For a start, the landlord would not let us leave the pram in the hall – it had to be taken upstairs – and there was the shared bathroom, where one morning a tramp was found sleeping in the bath. Heinke and Mark first went to Hamburg, and then stayed with my parents down in Hampshire; I searched for a place while staying with friends who were converting a house in Primrose Hill. Rick Mather, a young American architect who had come to work with Lyons, Israel & Ellis and had the loft apartment in this house, invited me to share. Each morning we walked to work across Regents Park to the office in Portland Place.

The most popular jazz record at this time was Stan Getz's *Jazz samba*, with Charlie Byrd. Not quite as interesting as his earlier *Focus*, it nevertheless caught the 'bossa nova' mood of the time. Getz came to play at Ronnie Scott's Club, when the house pianist was Stan Tracey. Asked later who he had most looked forward to playing with, Tracey replied 'Stan Getz – until he arrived'.

After much dispiriting searching for a landlord prepared to take a young family, I had at last a great offer from the sympathetic TV handyman Barry Bucknell: the ground floor and basement of a terraced house in Primrose Hill, without a kitchen, with a shared bathroom, and badly in need of attention. I could have it on a five-year lease for a low rent, if I was prepared to work on it. The house was shared with a retired zoo-keeper and his middle-aged daughter, who worked for the GPO. In the event, we stayed for twenty years, subletting while we were in America.

My time with Lyons, Israel & Ellis came to an end with a disagreement on the design of a large housing project, oddly next door to the Gaumont cinema in Southampton, where I had seen so many jazz concerts. Once again, one door had closed for another to open, thanks to Bob Maxwell, who took me to Douglas Stephen & Partners – he was one of the

Wyndham Court in central Southampton: a tough masterpiece of social architecture by Lyons, Israel & Ellis

partners. Edward Lyons asked how much I would be paid: it was another hundred pounds a year. 'Of course they could pay more – it's a commercial office', he sniffed.

Douglas Stephen's practice turned out to be very different from the paternalism of Lyons in particular. It was radical, even, with far more devolved responsibility. When I was joined by Edward Jones, we even bought a record player into our little office, for a jazz background while turning out working drawings. Situated just off Carnaby Street, we were in the heart of 'Swinging London'. Seeing a project through from design to completion helped me to complete my professional training.

Sadly, the work began to dry up, and my companion Edward left the office to beome part of the 'Neo Purist' group working for Frederick McManus & Partners. Spurred on by stories of Chicago from Adrian Gale, who had worked in Mies van der Rohe's office there, and a recommendation from Kenneth Frampton, I sent a small portfolio to the Chicago office of Skidmore, Owings & Merrill. In the meantime I was earning the extra money for the journey by redrawing projects at home for *Architectural Design* (its technical editor, Kenneth Frampton, was another partner in this office). I had heard nothing for what seemed a long time, when a reply in the form of a letter from Ken, now teaching in Princeton, lifted my spirits. He wrote (8 March 1965):

An end-on view of the office block in Watford for which I was job architect while at Douglas Stephen & Partners. Edward Lyons's remark about 'commercial architecture' would come back to haunt me. (Photo by Michael Carapetian)

> *The ways of God as they say are exceeding strange. Yesterday I received a letter from you entitled: 'HELP!'*
>
> *Today I receive a letter from Chicago entitled 'smart lad wanted'. More exactly I received a letter from Myron Goldsmith, saying that they have accepted you – and wish to write to you. The only snag being – with SOM being so efficient and all that – that they have lost (or conversely never had) your name and address. It's all very strange – perhaps Myron received work from some other fellow. I don't understand any of it.*
>
> *Needless to say I have written back right away – providing your name and address. So get moving boy – you have to pack for the Windy City.*

However, after his description in this letter of 'an urban paradise' in New York – the spot bounded by Grand Central Station, Charlie's Café, and the Hotel Biltmore – I determined to fly there first.

Waiting for a medical examination, which was part of the visa application, I found myself in the American Embassy waiting alongside David Hockney. Another Englishman, unaware of who he was, was trying to put him off Los Angeles, but he would have none of this. 'It's the most beautiful place in the world', he insisted.

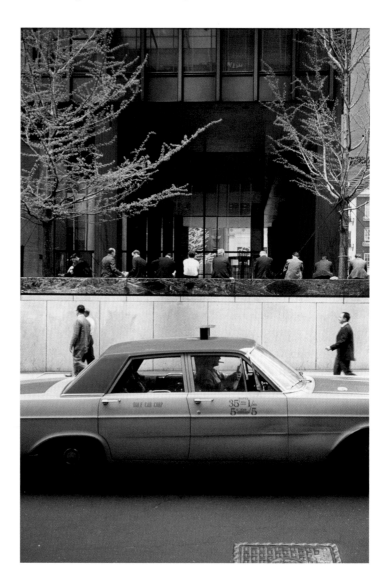

People sitting on the architecture: the Seagram Building plaza in New York

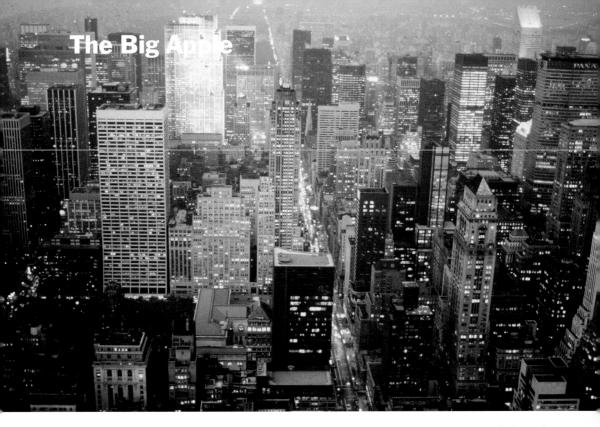

The Big Apple

According to my ID, which had to be carried at all times, I was admitted as a class X immigrant at New York on 3 May 1965. It was either the customs or immigration officer, chewing a cigar butt, who had invited me to 'step right up' and had welcomed me to the USA. A fellow passenger offered me a lift as far as the Port Authority building, and from there I took a yellow cab to the moderately priced Pickwick Hotel, which proved not at all Dickensian.

That evening, dizzy with excitement and jet lag, I was taken to dinner by Ken Frampton in a brasserie that formed part of the bustle at the rear of the sublime, bronze-clad Seagram building. The evening ended with us drinking Chivas Regal in Basie's Bar in Harlem, where the Shirley Scott Trio was in residence. What an introduction the 'Big Apple'.

The following day I leafed through the *New Yorker* and *Village Voice*, and saw the wealth of jazz on offer that week. Then I called in on the New York office of SOM. I was given a short tour of their recent buildings, from the majestic Chase Manhattan Bank to the superb little Pepsi

New York, photographed later by Mark Wild, from the Empire State Building. Four generations of the family have, by now, seen this changing panorama

27

Cola building on Park Avenue. Next on the agenda was the Museum of Modern Art, where I bought a print of Picasso's 'Guernica', which would become the first decoration in the apartment we would rent in Chicago.

That evening I went to the Five Spot Café for a double bill of the quartets of Lou Donaldson and Roland Kirk. The altoist Lou Donaldson had been on the first EP I had bought – of Milt Jackson's group – and was now enjoying great success as a leader. His Blue Note album *Gravy train* was a recognition of this: the track 'South of the border' is a good example of a more funky bossa nova than Stan Getz's. Roland Kirk was already known to us from the album *We free kings*, and would later visit England – playing to the animals in the zoo, or leading a troupe of whistle-blowing kids in Regent's Park. I remember him taking us out into the street from Ronnie Scott's, playing a Stevie Wonder song. To see him performing was something else, and I loved his acid wit. At the end of his session, after introducing the band, he said 'and my name is Stan Getz ... yeah, the white man who stole all Lester's licks before it snowed on him' (a reference to Lester Young's influence and Stan's drug addiction). A slight protest from the audience prompted him to admit 'I'm not bitter – just bitter-sweet'.

The next night was spent at the Village Vanguard, listening to Sonny Rollins. Some of the confidence of the famous Blue Note album recorded there seemed to have diminished; his experiments with Don Cherry and the 'New Thing' were not entirely convincing. The contrast with John Coltrane, who was then playing at the Half Note, was apparent. I had several Coltrane records already, the most recent being *Coltrane live at Birdland*, which contained a studio track, 'Alabama'. This haunted me. Swept away with the moment, seeing him standing in the Half Note with Jimmy Garrison during a break, I said how moved I was by it, and even asked if he might play this piece. This was just the first of several meetings with this true giant and his continually evolving music. It didn't strike me at the time, but I did not have to queue or book for any of these clubs, and I always had a table. It was not particularly expensive, either.

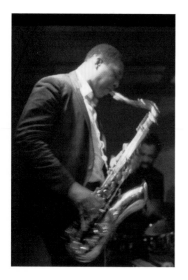

John Coltrane phographed in Detroit

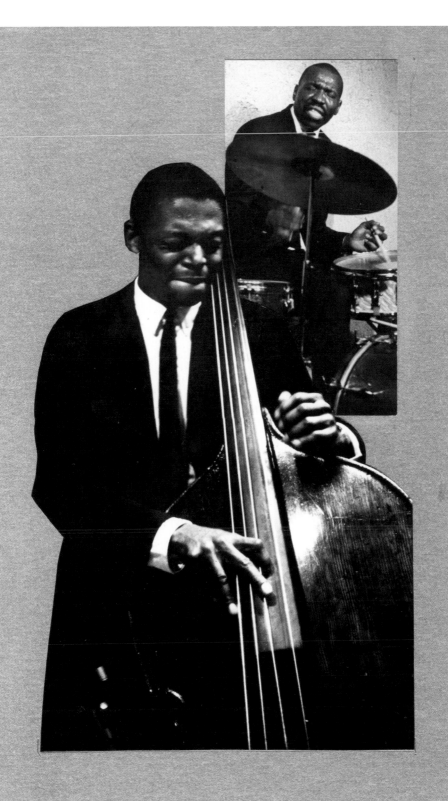

Going to Chicago

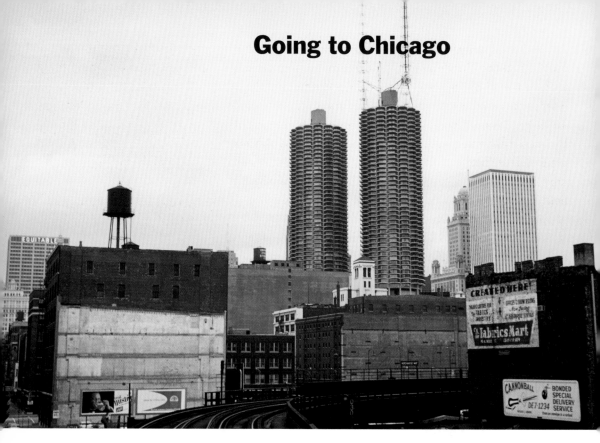

Goldberg's Marina City towers – the 'corn cobs' marking the entry to the downtown loop

I had to be at work in Chicago the following Monday, and the artist to whom we had sublet our flat in London had arranged for me to stay with her parents on the Sunday, in Winnetka, outside Chicago. Arriving by cab at noon, I found myself welcomed into a house interior straight out of a Douglas Sirk movie. A cocktail was thrust into my hand, and as soon as this was downed we set off to the country club for lunch. Some drinks later, I was given a lecture on how Roosevelt had tried to bring socialism to the USA. I dreaded to think what they would have made of their daughter's new quarters back in London – technically a slum, with no kitchen and a shared toilet and bathroom.

Next morning, bright and early, I swept into Chicago on the commuter train, past the rust-red Cor-ten steel-clad Civic Centre: a magnificent contemporary example of the 'Chicago frame' and the latest addition to a living museum of modern office buildings along Dearborn Avenue. Still clutching my holdall, I arrived at the Inland Steel building, home of the SOM offices. To my dismay, I was put to work

straight away drawing toilet partitions for a hexagonal
building on the University of Illinois campus. The project
architect with whom I was to work, Will Reuter, kindly
offered me a bed until I found an apartment. In spite of this
kindness, I was ready to turn right around. I had thought
I was going to work with Myron Goldsmith in the Miesian
wing of the office, and luckily this was the case. I spent the
next months on the design and working drawings of the
field house for the IIT campus, under the leadership
of Michael Pado. I even made a presentation model.

*Michael Pado keeping a watchful
eye on my draughting skills.
(Photo: Michael Pado archive)*

 That first weekend I had seen an inviting poster for
a blues concert: B. B. King, Muddy Waters, Otis Spann,
Howlin' Wolf, and others. It was at the Regal Theatre on
the South Side. As I got off the El – the elevated railway –
a young black guy blocked my path: 'Got the wrong stop,
man?' 'Isn't this the right stop for the Regal Theatre?', I
said innocently. 'Hey, man – you're English – that's cool',

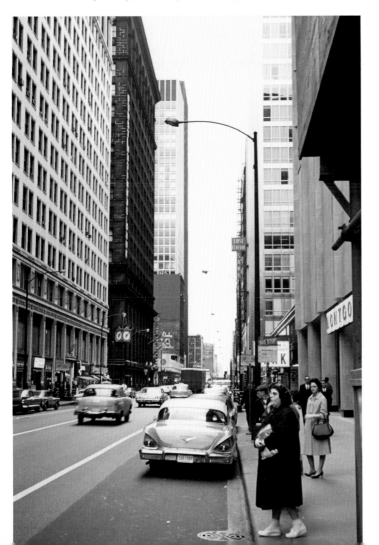

*The very window at which I
worked, on the fifth floor of the
Inland Steel building (background,
right), can be seen in this view from
Dearborn Avenue*

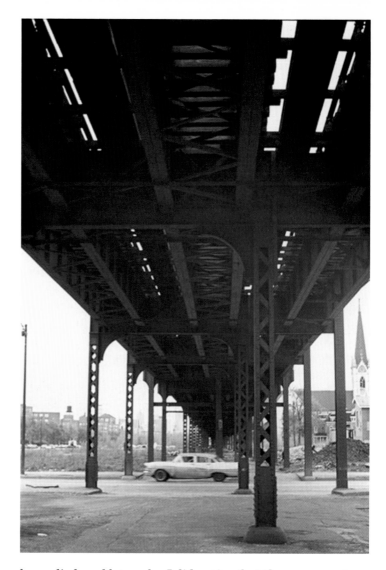

Underneath the 'El' on the South Side

A typical station automat – but why the mirrors?

he replied, and let me by. I did notice that there were not a lot of white faces at the concert. But the general atmosphere was so overwhelming, I didn't give it much thought. When I was asked back at work how I had spent my first weekend in Chicago, I was told I must be out of my mind. Such a trip was seen as both unnecessary and dangerous; it was true that there weren't any jazz fans in the office. There were Bob Dylan fans, though, for whom 'Maggie's Farm' was an appropriate favourite. I admit that I was also an enthusiast, and was soon quoting lines in letters home.

It didn't take long to find an apartment within easy reach of the so-called 'Old Town', where there were several jazz clubs and bars. With my first paycheck I opened an account at the Chase Manhattan Bank, and took out a subscription to *Downbeat* magazine, which came with a free LP: a Blue Note anniversary album. My US collection was started. There was some jazz on the local radio, with which I had to make do until I could afford a stereo system. After this, most of the records were bought from Morrie's Met Music Shop on the South Side, via the same El station at which I had arrived on that first visit to the Regal Theatre.

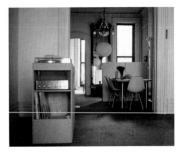

Our apartment on Belden Avenue in the near North Side. The boxes in which the Eames chairs came were used as a room divider. The first few LPs sit inside the home-made record deck

Looking for some blues records at the shop ('There's no real demand for them save for a few college kids', Morrie confided), I found the matchless Robert Johnson collection that featured on the cover of Bob Dylan's *Bringing it all back home*, and an interesting Atlantic album, *These are my roots: Clifford Jordan plays Leadbelly*, which proved hugely enjoyable: another great tenor player from Chicago.

The SOM office was hierarchical and efficient; all except the partners had to clock in and out – the advantage of this was that you were paid for overtime. Another benefit of being an employee was that I was able to furnish the apartment at cost price. It was already very hot; and as soon as I could afford it, I went for one of those lightweight suits that the Jimmy Giuffre trio wore in *Jazz on a summer's day*. Swimming in the lake helped, but later resulted in a sinus infection – no one had warned about the pollution level. A beneficial side-effect was that this stopped me smoking.

There was plenty of jazz to be heard after work, both live and on juke boxes in several of the bars. A favourite spot with a Hammond organ in the window had Jimmy Smith on Father's Day, joined by his dad, who got an ovation for singing the blues. The favourite blues spot hosted the Paul Butterfield Blues Band.

Heinke and Mark flew out to join me in July: he was the same age as I had been, arriving in America as a child. His longer hair and English accent accorded him preferential treatment wherever we went. Michael Pado, who had become both mentor and good friend, drove me out to collect them from O'Hare, where I was even allowed on the tarmac to see them disembark. As an interesting introduction to

Mark's ID photo

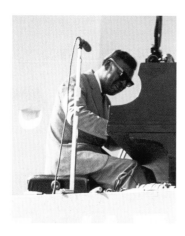

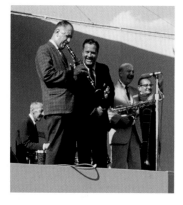

Top: Earl Hines

Above: Pee Wee Russell with Jimmy McPartland, Bud Freeman, and George Wettling (at the rear)

Opposite page: 'Giant steps' – John Coltrane and Chicago

the lakefront city, he arranged a picnic for us on his sailing boat. Unfortunately we were too seasick to eat anything, and a heat haze prevented me from getting the photograph I had hoped for from this viewpoint, of Mies van der Rohe's famous Lakeshore Drive apartments.

Heinke and Mark had arrived in time for the summer Downbeat Jazz Festival in Soldiers Field, and we all went to an afternoon session that included some blues by Big Joe Williams, a memorable reunion of older Chicago-style players, and, finally, piano master Earl Hines, now back on the circuit after a period of woeful neglect. His brilliant duets with Louis Armstrong, made half a lifetime before, remain unsurpassed. The following evening included one of the last appearances of the original John Coltrane quartet, with Archie Shepp added. Under a starry August sky, this was an unforgettable experience, and included an amazing bass solo by Jimmy Garrison.

A colleague at the office had asked if we were going home for Christmas – of course, we couldn't afford to – and then insisted that we join his family on Christmas Day. There, under a grand Christmas tree was a bottle of Chivas Regal, Chanel no. 5, and a box of 'Tinker Toy' for Mark. We sat down to a scrumptious turkey dinner, served by the cook, who, after washing up, could make her way back to her family on the South Side. Were we naïve to feel uncomfortable about this?

That first winter Mark was seriously ill, and we had a brutal introduction to the cost of health care. There had also been a near accident as we all came out of a cinema from a matinee showing of *Those magnificent men in their flying machines*. Mark, still holding our hands, was blown horizontal as we hung on to the traffic barrier – welcome to the Windy City. Summer humidity, winter ice storms: everything about Chicago seemed extreme – including the gap between rich and poor.

We did not have any difficulty in finding baby-sitters, so were able to get out to catch some jazz or a film like *Mickey One*, shot in Chicago and with a soundtrack by Eddie Sauter and Stan Getz – an echo of the *Focus* album. The first visit to the Plugged Nickel was to hear Charles Lloyd with a group that included Gábor Szabó, whom I had heard on a

air mail
TEAL

32 USA
THELONIOUS MONK

Cadillac
STANDARD OF THE WORLD

Chico Hamilton album of 1963. The club was almost empty, but, as he explained later, it was subsidized by the record company to get 'exposure'. Heinke took pity and invited the musicians to dinner, which was much appreciated. Just a short time later, Lloyd was the hit of the 1966 Monterey Jazz Festival with *Forest flower* and a brilliant new pianist – Keith Jarrett.

Charles Lloyd was one of a new generation of university-trained musicians; while they extended the scope of jazz, the personal sound of the largely self-taught jazzman, most evident with the saxophonists, would be lost. The days would soon be over when Errol Garner – complimented on his composition 'Misty' as having echoes of Debussy – angrily demanded 'where's he playing?' Duke Ellington's orchestra of individuals could be seen as the apogee of instantly recognizable voices within the collective. The jazz workshops of George Russell and Charles Mingus continued the synthesis of composition and improvisation. Russell's 'Concerto for Billy the Kid' or Gil Evans's 'Blues for Pablo' followed the example set by Ellington's 'Concerto for Cootie'.

One weekend, Ken Frampton came down from Princeton and we all went to see Oscar Peterson playing at the London House. One of the first records I ever bought was a Peterson single; his driving accompaniment had been a feature of the best Jazz at the Philharmonic concerts, and the album *Night train* was a favourite. The evening got off to a bad start with the London House doorman refusing to let Heinke in, as she was wearing a trouser suit. Finally inside, after a quick change, the venue proved unsympathetic, with chattering diners and clattering dishes. Peterson's playing had received even more brusque treatment at this time from Thelonious Monk, who, in an abortive 'blindfold test' by *Downbeat* magazine, requested to go to the toilet as soon as the Peterson record started. Asked if this might be taken as a comment on the playing, he replied that Bud Powell had spoiled him for everybody else.

Thanks to a design consultant for SOM who lived on the South Side of Chicago, and whose friend worked for *Downbeat* magazine, I was becoming more aware of jazz developments. The most important of these was the AACM – the Association for the Advancement of Creative Musicians – a

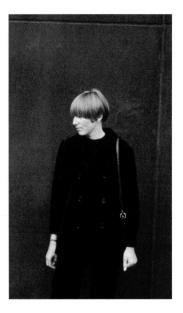

Heinke in the offending trouser suit against a Cor-ten steel backdrop

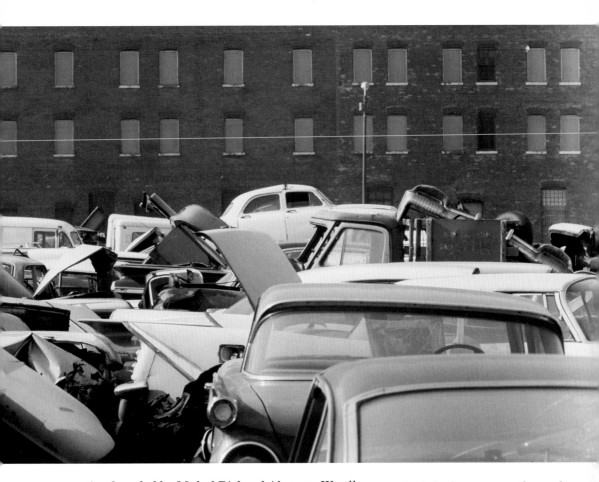

co-operative founded by Muhal Richard Abrams. We all went to one of their afternoon concerts: more of a family affair and worlds away from the nightclub milieu. Here I heard Roscoe Mitchell and Joseph Jarman for the first time. Roscoe had just recorded *Sound* for the Delmark label, which I bought immediately. They would subsequently become part of the Art Ensemble of Chicago; the term 'jazz' was seen by them as having too many derogatory connotations. Another musician I discovered at this time, sadly only on record, was the neglected Andrew Hill: his *Point of departure* on Blue Note, featuring Eric Dolphy, Kenny Dorham, and Joe Henderson, is a masterpiece of the 1960s. He had even written an open letter to *Downbeat* magazine, titled 'send money'.

'Moloch whose eyes are a thousand blind windows' (Allen Ginsberg, Howl)

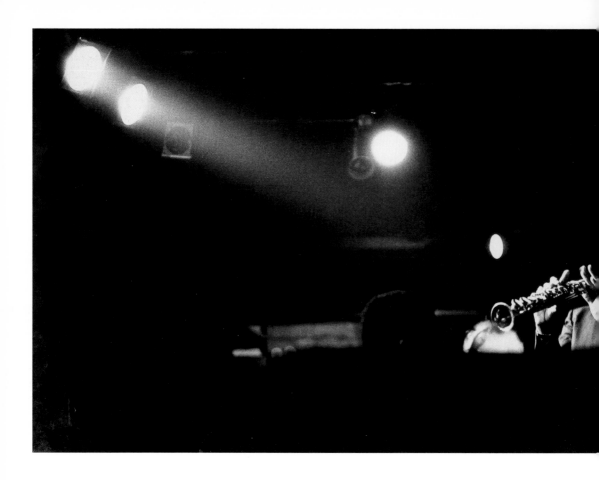

Declan

Heinke and Mark had made friends in the park with the Haun family, and I would soon meet Declan, the photographer father. He worked for the Black Star agency and already had work in the Museum of Modern Art. We became friends and he encouraged my photographing to go several steps further. He found me a second-hand Nikon F2 body, as well as giving me his Weston light meter, which he didn't need any more, having a perfect sense of light quality. Armed with this superior camera I started on photo-walks.

Declan had come with us to listen to John Coltrane at the Plugged Nickel, and took some pictures for me. The night we were there, Roscoe Mitchell sat in for one number and the drummer Jack DeJohnette joined Rashied Ali. Pharoah Saunders had also now joined the group, and

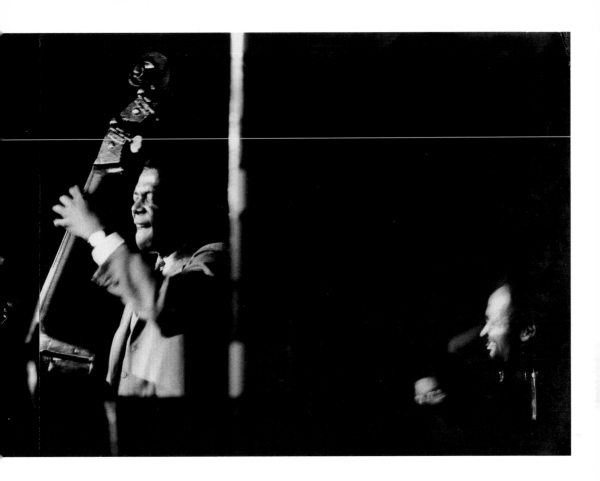

Montage of two photographs taken by Declan Haun. Shortly after we got back to England he sent a copy of Life *magazine with his extraordinary double-page view of Detroit during the riots of August 1967. We stayed in contact for some years. He died in 1994*

there was something of the feel of the remarkable collective improvisation on the album *Ascension* – certainly the two drummers were needed to replace Elvin Jones, who, with McCoy Tyner, had left Coltrane after that recording.

Declan introduced me to some of his colleagues, including Maurice Rosen, whose photographs of Roland Kirk formed part of the wonderful *Rip, rig and panic*, surely the best recorded Roland. The short-lived Limelight label also produced a superb *The immortal Clifford Brown* double album, and Eric Dolphy's *Last date*, recorded in Hilversum, with Dolphy's voice eerily ending the session with 'when you hear music after it's over, it's gone, in the air – you can never capture it again'. Luckily, we could.

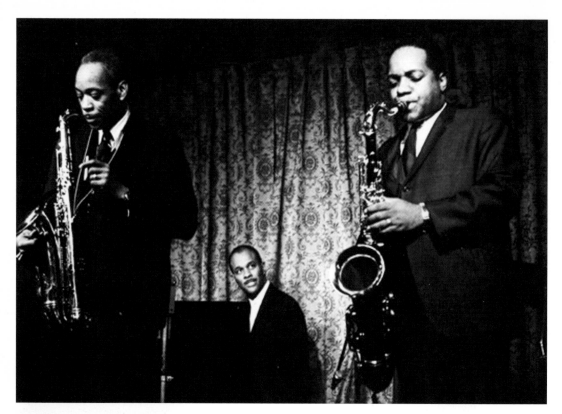

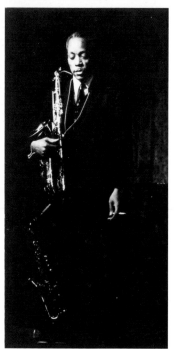

My first shots were of a session with Sonny Stitt and
Eddie Harris. Stitt seemed the epitome of cool as he waited
to solo – was that a herbal cigarette he drew on so heavily?
Sonny Stitt, together with Dizzy Gillespie and John Lewis,
had been on a Norman Grantz album *The modern jazz
sextet*, with one of those great David Stone Martin cover
drawings. The ballad tracks closed with 'Blues for Bird',
with John Lewis providing a superb introduction: together
with Lennie Tristano's 'Requiem', the best piano tribute to
the lost master. Both Stitt and Harris had jukebox hits us-
ing the electronic saxophone. This bizarre instrument – the
electronics helping to further diminish individual voicing
– was more suited to Harris's popular style, while Stitt was
perhaps just happy not to sound like Bird any more, having
already switched from alto to tenor.

*Taking a leaf out of Declan's book,
I would use available light only.
By pushing the developing, the
already fast Tri-X film could be
rated at 800 ASA*

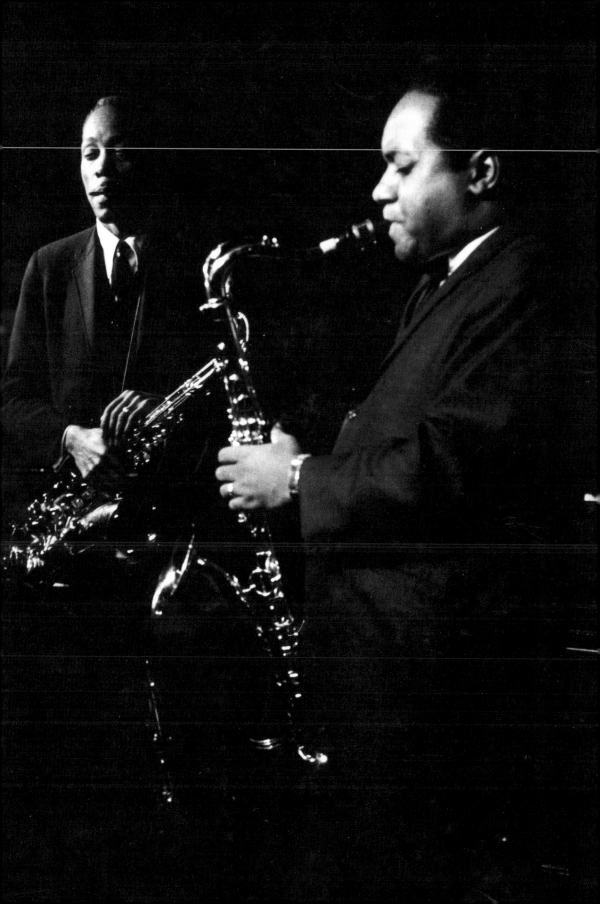

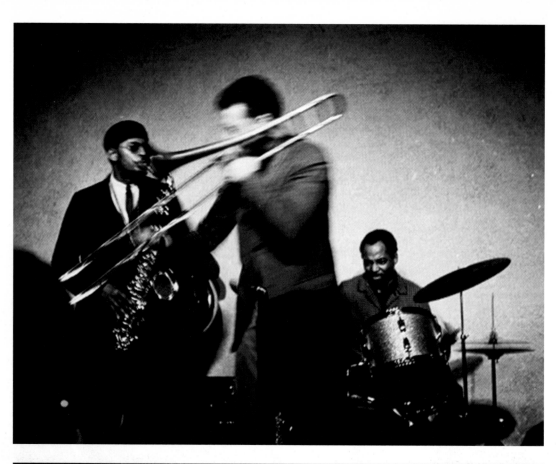
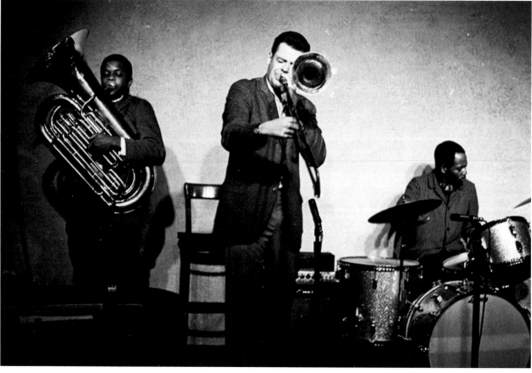

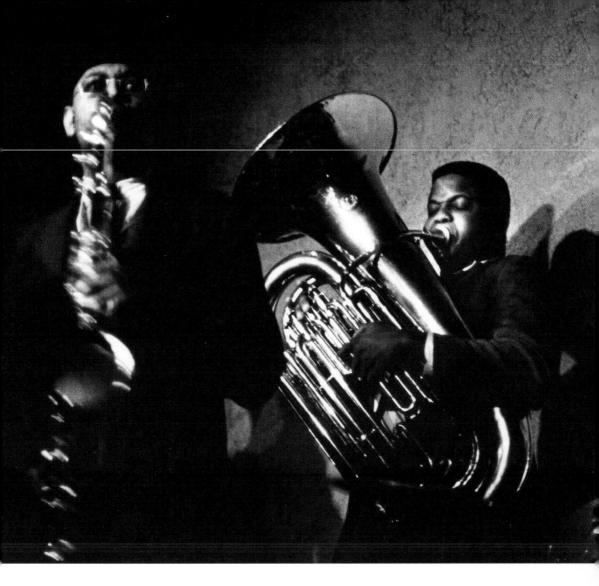

The next outing was more visceral: a band led by Archie Shepp, one of Coltrane's protégés, at the Hungry Eye club. His poem 'Tracks', which was first read at the Newport Jazz Festival, became the inspiration for a photomontage.

Archie Shepp's appearance at Newport may have gone under the title of 'New Thing' but closer listening revealed deep roots in the jazz tradition: the exciting group at the Hungry Eye had echoes of New Orleans marching bands, including the use of the tuba. Roswell Rudd's declamatory slide trombone playing also contained echoes of the early 'tailgate' tradition. I liked Shepp's poetry as well; together with Leroi Jones's, this added a darker, more political edge to the poetry and jazz of the New York 'beatniks'.

Opposite page and above:
Archie Shepp (tenor saxophone),
Roswell Rudd (trombone), Howard
Johnson (tuba), Beaver Harris
(drums)

Overleaf: 'Where tracks is, the
money ain't'. The opening line of
Shepp's poem was the inspiration
for this montage from Chicago,
including the Maxwell Street shot
admired by Transaction's editor for
its depiction of 'so many different
types of poor people' (p. 72)

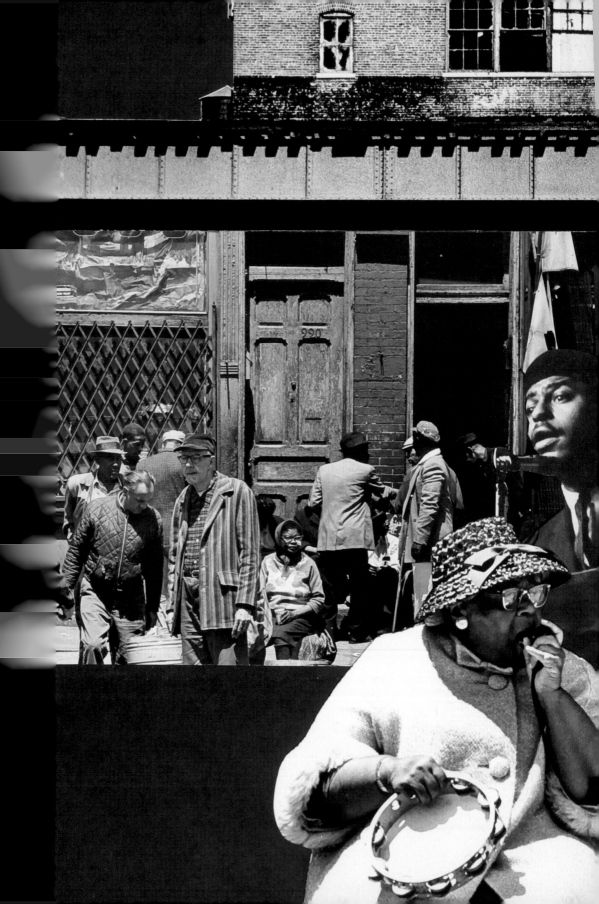

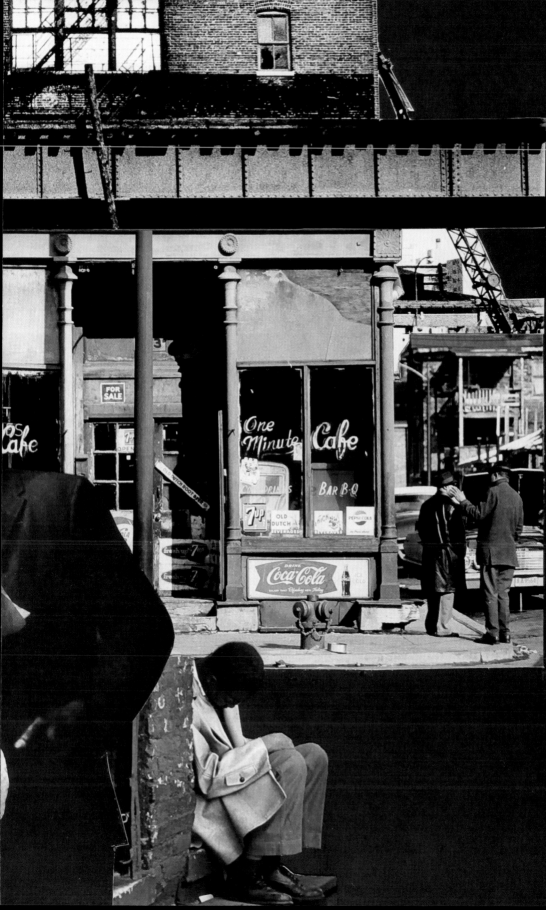

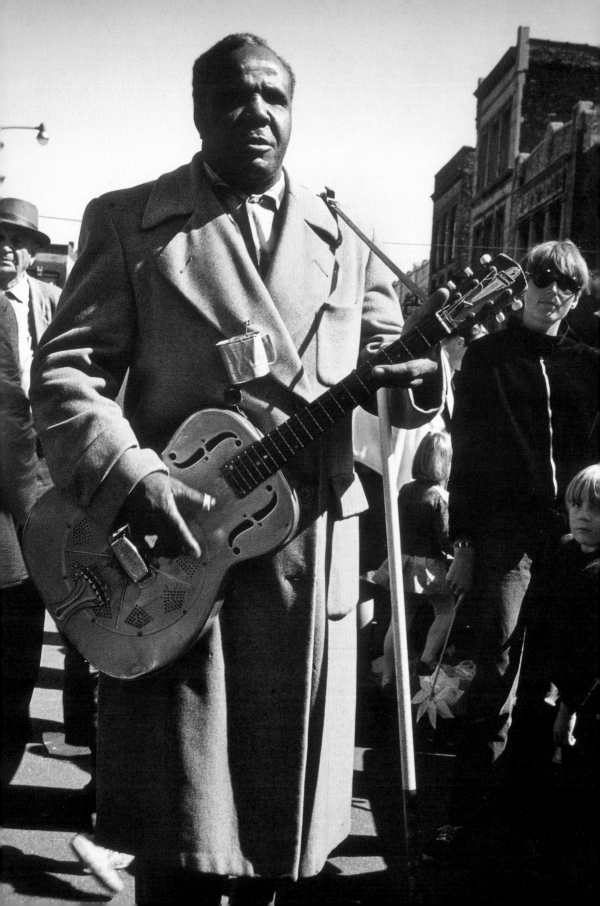

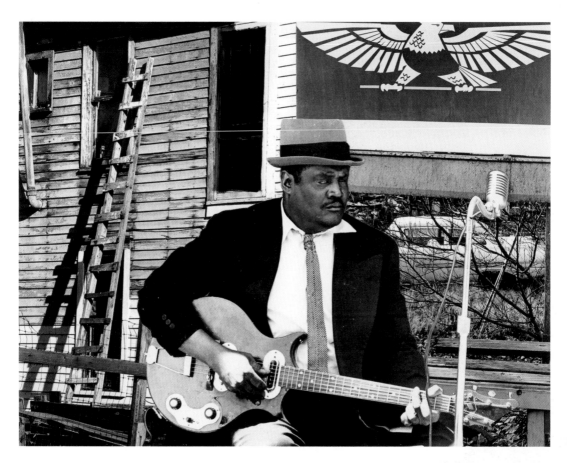

On a sunny day in early May we visited Maxwell Street, the famous Chicago street market. Originally the home of immigrant traders from Russia at the turn of the century, it became a magnet for itinerant blues musicians and still hosted a variety of informal street music. The impressive figure of Blind Arvella Gray, with his steel guitar and tin cup, was identified later by Paul Oliver, who had included him in the book *Conversations with the blues*. A 1980 film *Maxwell Street blues*, by Linda Williams and Raul Zaritsky for the University of Illinois Media Center, helped identify the singer Carrie Robinson and guitarist Jim Brewer. Both had moved from blues to spirituals: a not uncommon result of being, in Carrie Robinson's own words, 'saved', while her joyful dancing testified to this. The film also included some Super 8 mm film shot by Arvella, who also owned a little projector as part of his bizarre hobby.

Top: The picture of Jim Brewer has been montaged to a more rural setting
Above: New Mount Zion Baptist Church, Maxwell Street

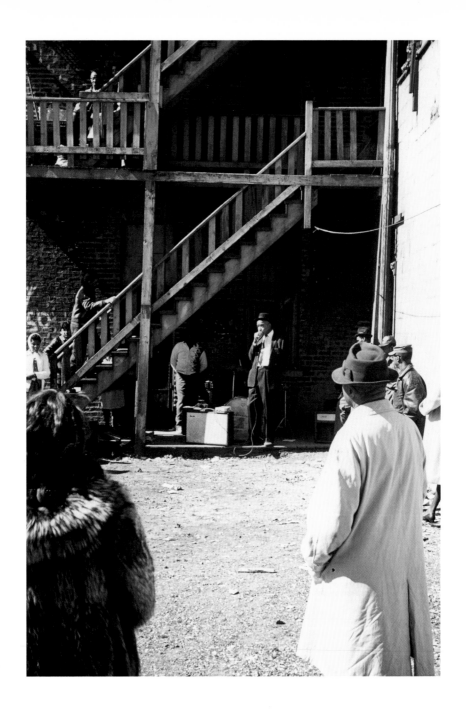

Above: The MC sets the scene

Opposite page: guitar, drums, and harmonica, perform under a back stoop

Overleaf: 'Saved!' Carrie Robinson

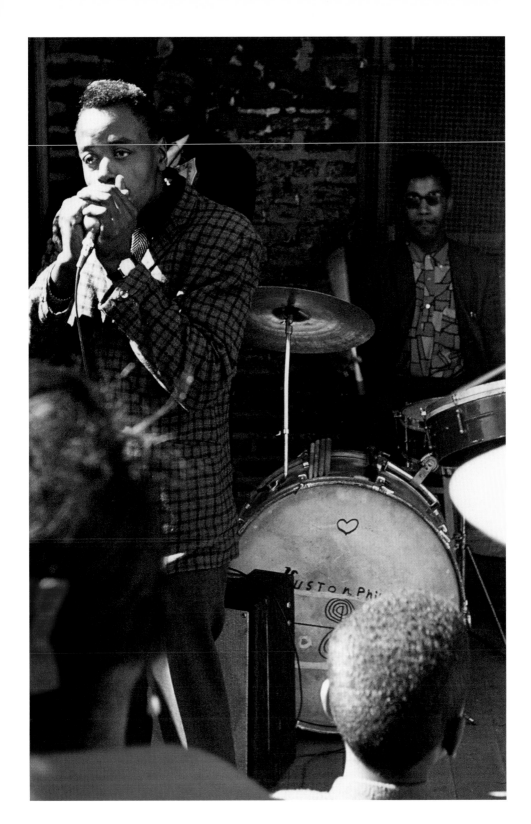

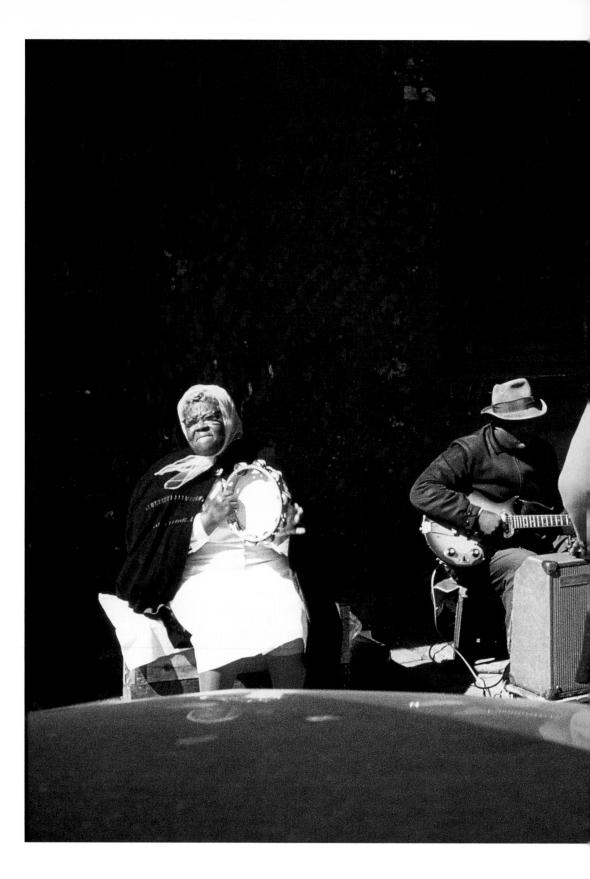

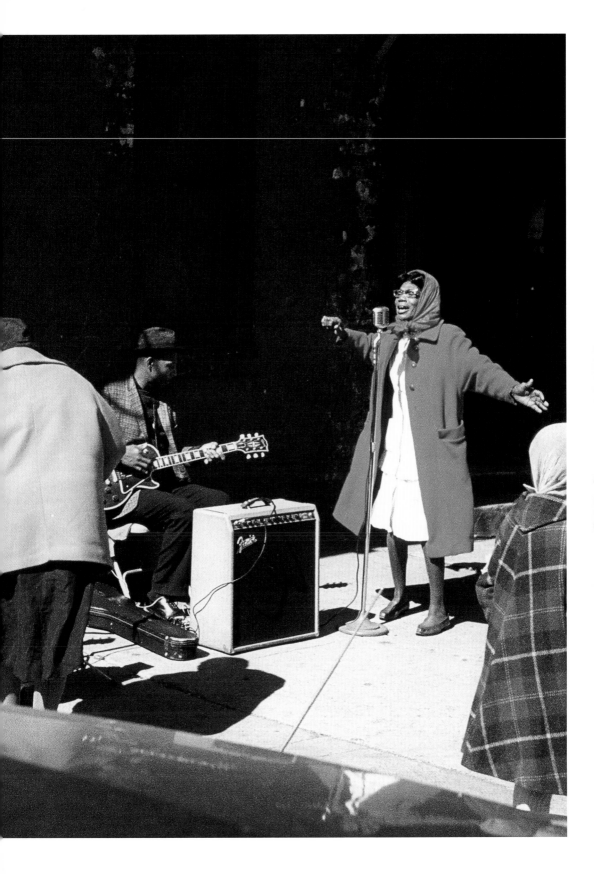

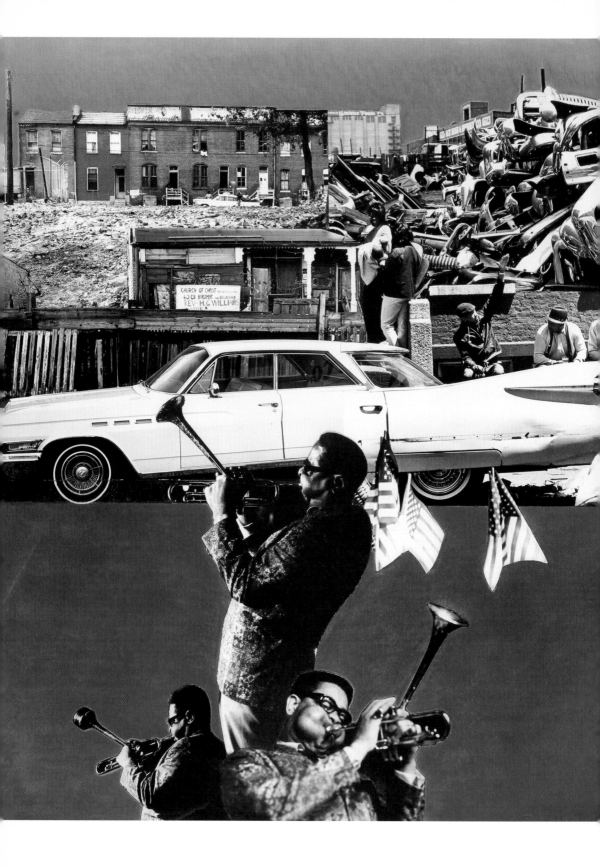

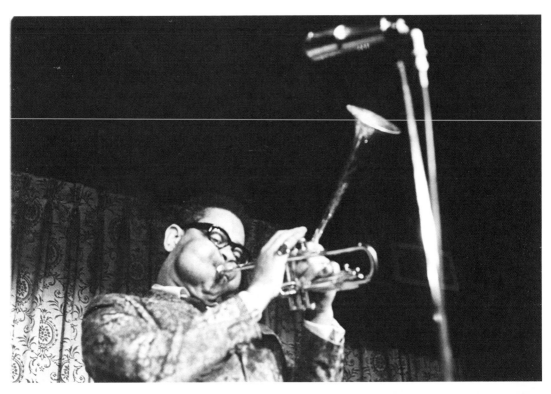

Dizzy Gillespie was the next visitor to the Plugged Nickel. With the hallmark raised trumpet bell, he could still hit the high notes. For all the frighteningly inflated cheeks, though, some of the bite was gone, as was the competition of playing alongside Parker – especially as heard in the justly famous Massey Hall concert recording. The attack he delivers on the early Bluebird recording of 'Night in Tunisia' with Milt Jackson and Lucky Thompson remains a superb example of the sheer excitement of bebop. 'Swing low, sweet Cadillac', his ironic version of the spiritual, became the starting point for another montage. Walking down South State Street to the IIT campus, I had become fascinated by the auto graveyards: Al's Auto Parts were friendly, while at another lot I was stopped at gunpoint and subsequently accused of being part of Lady Bird Johnson's 'clean-up' campaign. While the suburbs of Chicago seemed to go on forever, St Louis faded into rural poverty – if not the 'one room country shack' of the blues songs, then close enough to it. Here the dumped car body by the wooods seemed to be used for target practice.

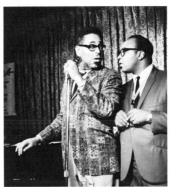

Top: Dizzy at the Plugged Nickel.
Above: Dizzy and James Moody banter

Opposite page: 'Swing low, sweet Cadillac'

Overleaf: 'Automobile blues'

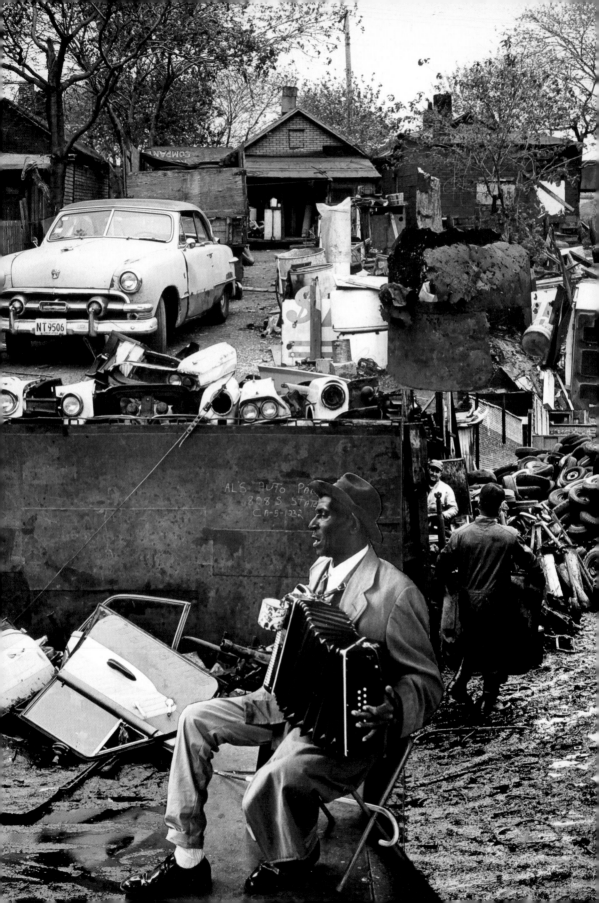

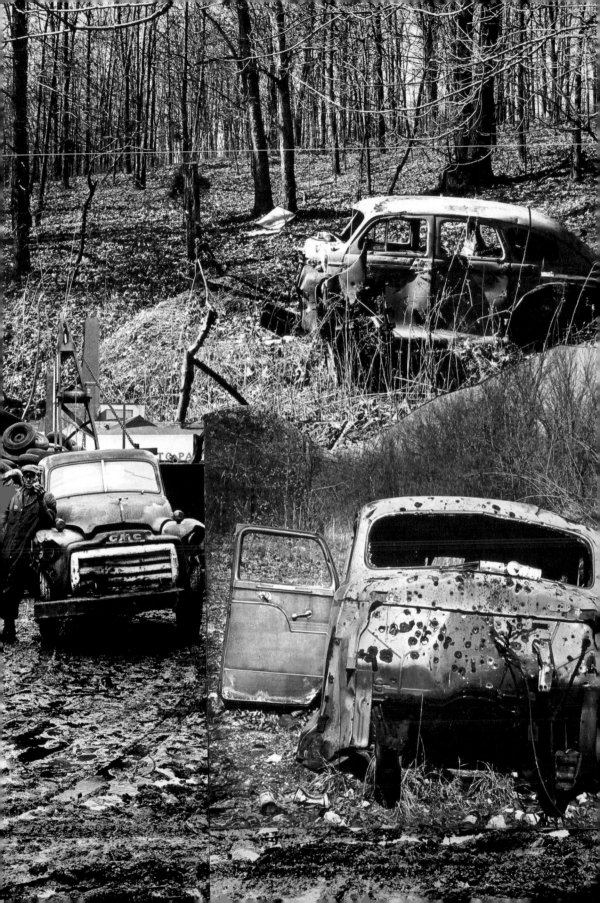

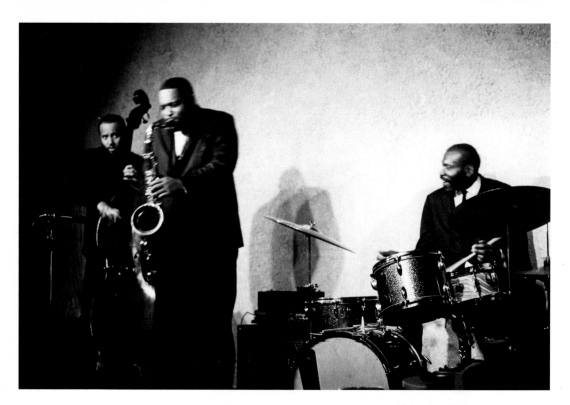

Elvin Jones trio: saxophonist and bassist cannot be identified.

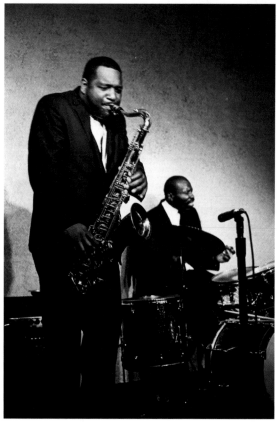

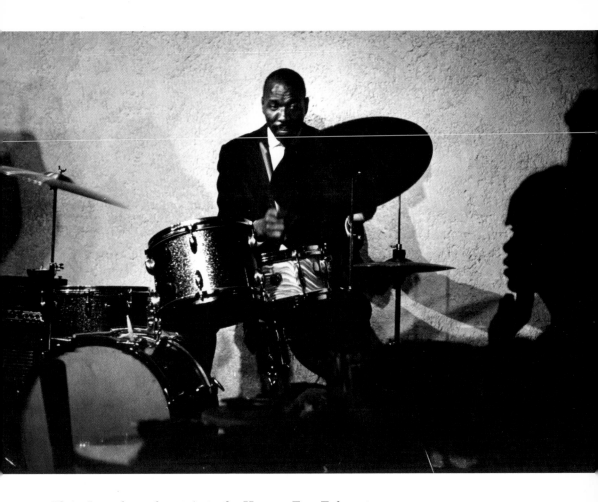

Elvin Jones brought a trio to the Hungry Eye. Exhausted by the two massive takes of the *Ascension* recording, and less than happy with the introduction of Rashied Ali's freer drumming that marked Coltrane's departure from regular time structures, he left the group. He would appear with various tenor players, even including a recording with Sonny Rollins, *East Broadway run down* on Impulse, but the intensity of those sessions with Coltrane would never be matched. His love and admiration for that leader is beautifully recorded in a superb documentary film, *The Coltrane legacy*.

Elvin Jones's playing on 'Alabama' is a superb instance of controlled emotion. As Leroi Jones wrote in his sleeve-notes to *Coltrane live at Birdland*: 'a slow delicate introspective sadness, almost hopelessness, except for Elvin, rising in the background like something out of nature ... a growing thunder, storm clouds or jungle war clouds.'

Above: Elvin clearly had an admirer in the audience.

57

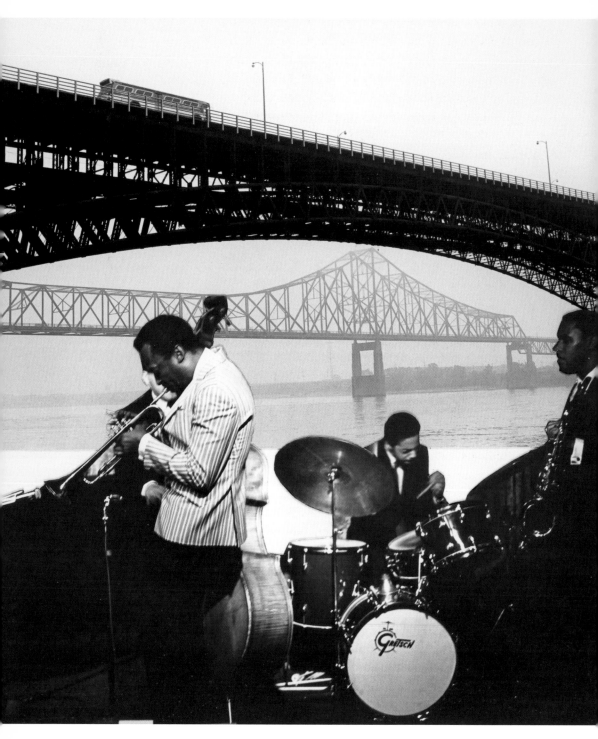

Miles Davis montage: leaving St Louis. Tony Williams on drums, Wayne Shorter on tenor saxophone, Ron Carter on bass, Herbie Hancock – off camera – on piano

We had missed Miles Davis's visit to the Plugged Nickel in December of the previous year, while Mark was so ill, but here he was again with that great quintet – and the earlier session would be made available on record. If Bird and Diz had been the giants of the 1940s, Miles and 'Trane were certainly the next brilliant pair. Along with many other musicians at that time, both had been heroin addicts; but when Miles finally dropped Coltrane because of his unreliability, Coltrane determined to kick the habit. There is an example of him nodding off on the Thelonious Monk album *Monk's music* – after his piano solo Monk shouts 'Coltrane! Coltrane!', who comes in straight away. Legend has it that Coltrane could catch forty winks with the horn in his mouth. (Coleman Hawkins does much better on this session – his solo on 'Ruby, my dear' is just about perfect.) Free of his addiction, his faith and the music became stronger, culminating in the valedictory *A love supreme*.

Miles Davis would also go 'cold turkey'. But while Coltrane aspired to a sort of saintliness, Miles went another way. With album titles like *Bitches brew* and *Live–evil*, he became more like a rock star: especially with his dress. Underneath all this remained an extreme sensitivity that would emerge whenever he played a ballad.

I didn't get a chance to see the other great innovator and early partner with Miles when they played with Parker – drummer Max Roach. His political stance, and the album *We insist!*, had made club owners reluctant to book him. There was, however, an Atlantic record just out: *Drums unlimited*, with a marvellous opening track, 'The drum also waltzes' – a solo masterpiece. These recordings couldn't match the standard set by his group with the late, brilliant Clifford Brown. It was much later that he brought a group to the Purcell Room, on London's South Bank, and as he came on stage we all stood up in a spontaneous accolade. Max responded to this extraordinary occurrence by telling us a little about the early days with Charlie Parker. He and Miles Davis tried again and again to keep up, but they were just blown away. 'Yeah,' said Miles later, 'and then he died before we could get even.'

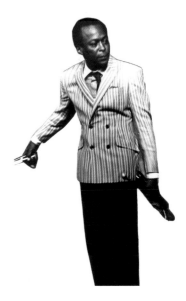

'Miles Davis plays pretty well for a millionaire': Cecil Taylor, quoted in A.B. Spellman's Four lives in the bebop business *(1966)*

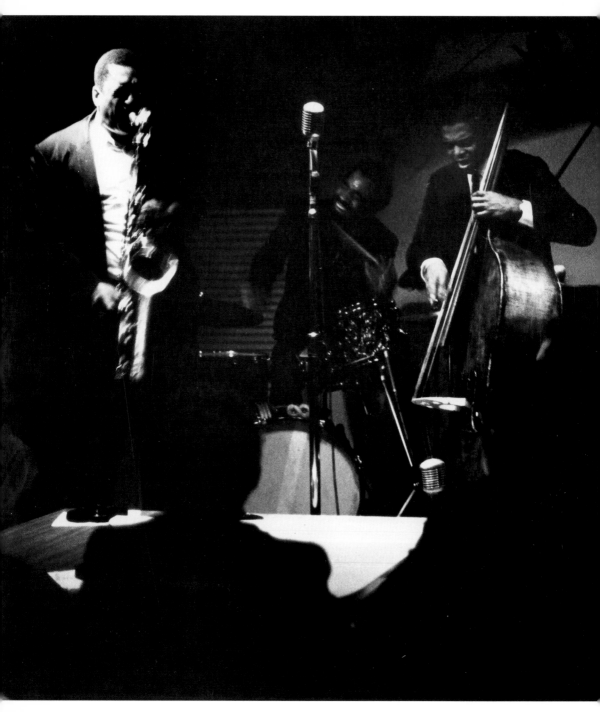

*John Coltrane, Rashied Ali, Jimmy
Garrison, with Alice Coltrane and
Pharoah Sanders out of picture*

Detroit

By far the most memorable trip we made from Chicago was to Detroit, where John Coltrane was taking part in a Black Arts Festival. Mark was left with friends Ben and Cindy Weese, and we were driven up in an old chauffeur-style Mercedes by fellow architect Peter Forbes, who had been left this in an aunty's will. As a joke, he parked outside the office; wearing a hat and dark glasses, he held the door open for us and saluted. This started a rumour about an eccentric English aristocrat that I was loath to deny. We were to stay in Detroit with another aunty, whose nephew, the office junior, came with us. When we stopped outside Chicago for supper, he at first didn't want to get out of the car. We insisted that he come and eat with us, but he was perspiring with fear in this all-white suburb. We had been naïve again.

I had arrived in New York in time to catch the original Coltrane quartet. Now, in Detroit, the drummer Rashied Ali had replaced Elvin Jones, while his wife Alice had taken over from McCoy Tyner, and Pharoah Sanders was an added horn. Gone was the relentless forward drive, as on 'Impressions', memorably recorded on film in *The Coltrane legacy*; now the solos seemed to hover over a sea of rhythm in an extended quasi-mystical present, surely influenced by his use of LSD. If the album *A love supreme* marked the apotheosis of the Coltrane quartet, the music now found more scope beyond the rhythmic constraints of earlier jazz, moving into a freer expression of 'the joy and suffering of the negro in America', as predicted in a remarkable polemic by Edward O. Bland, filmed as *The cry of jazz* by KHTB Chicago in 1959, with a great soundtrack by members of the Sun Ra Arkestra. Coltrane had been well known for extended improvisations; once asked why he played so long, he replied 'I was looking for something good to stop on', to which Miles Davis replied 'take the horn out of your mouth'. In the Detroit club, I saw the manager use another method: he simply yanked Coltrane's

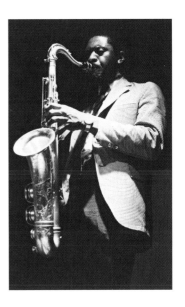

Portrait of Pharoah

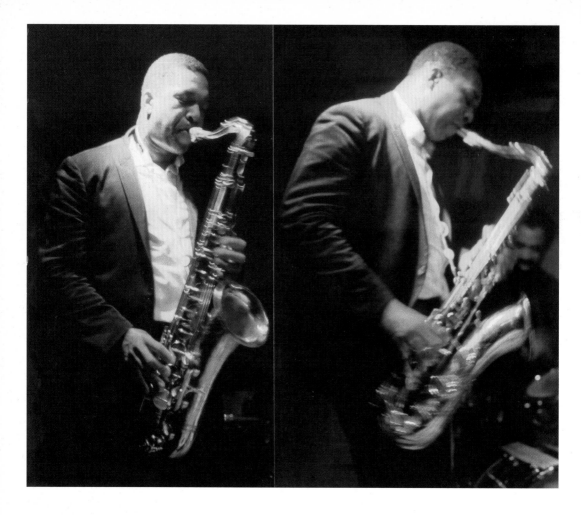

A side effect of the slow colour film was to catch the sense of movement; I had also experimented with double exposures
Above: John Coltrane
Opposite page: Pharoah Sanders

jacket. With effortless grace, the unruffled master brought his solo to a close.

Also photographing at the club was Leni Sinclair, another German jazz fan and wife of poet and activist John Sinclair, in prison at that time. (His band, the MC5, occupies a special place in the history of the motor city's music.) We met up after the session, with the group waiting outside. Pharaoh Sanders stood in silent contemplation of the starry sky. We were invited back by Leni and I came away with a mimeographed magazine edited by John, containing his poetic response to such music, a couple of Leni's photos, and an interview with Archie Shepp.

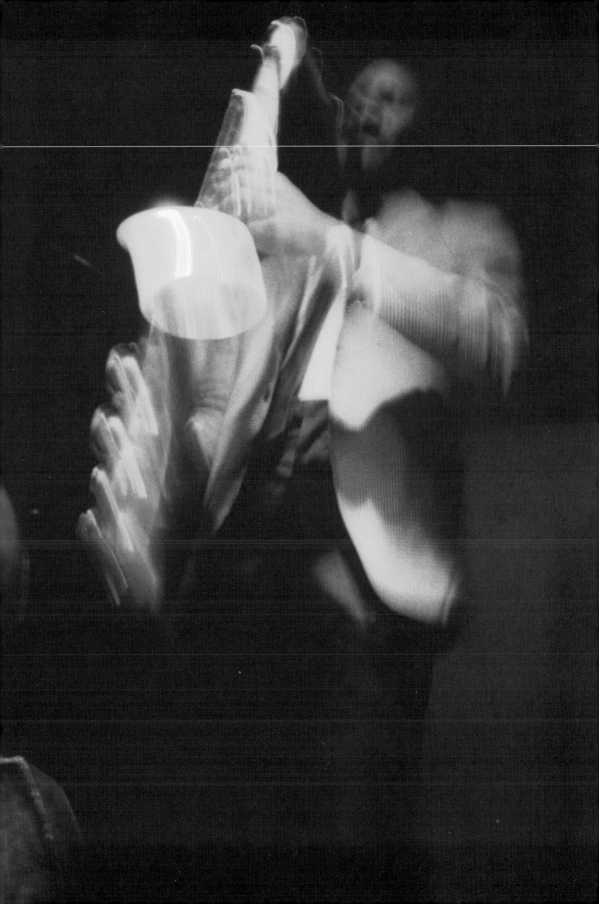

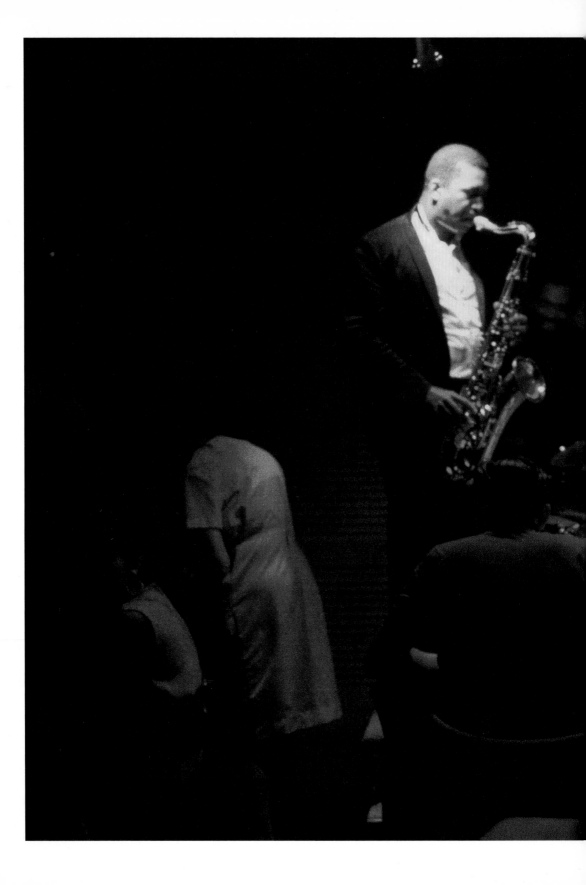

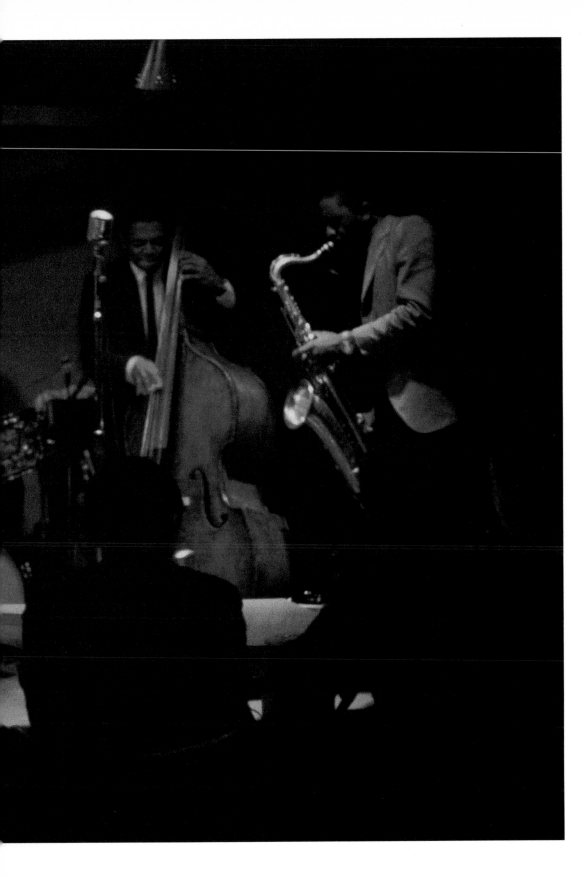

United Airlines office: the twin black-pained extra supports can just be seen behind the original structure

The gulf between such nights and the routine of the office was becoming difficult. It was around this time that I lost my temper with a new job architect whose mistake would cost me a day's redrawing work. 'You bloody idiot', I said, grabbing his arm. 'Gee, David,' he replied, 'where's your aplomb?' I had been fortunate to arrive in Chicago in time to see the IIT gymnasium through to construction drawings, but now was working on simpler office buildings, including an extension to the United Airlines headquarters. This suburban, low-rise building had been hailed for its shallow pre-stressed concrete structure of sixty-foot-square bays, but had subsequently required remedial support, so we now had to match this profile in steel. On a site visit to the existing building, we were standing in a vast feature-less space of office workers at identical desks, uniformly lit from the ceiling grid. I felt a migraine coming on, as Myron calmly gazed upward. After some time, he spoke in his slow and distinct manner: 'You know, I still can't decide if the joints in the ceiling panel should be butt, or mitred.' It was time to leave; the lease on the apartment was up, and we prepared to return home.

All packed and ready to go, we had found a temporary home in the basement of Ben and Cindy Weese's house, when a teaching opportunity arose at the Washington University School of Architecture, in St Louis. I flew down for an informal interview, and was offered the job. There had been a moment of blind panic when I just missed the plane. I hadn't known that I could use the same ticket and simply catch the next flight out. When it was returned to me, a clerical error let me see the notes in the margin of my reference, made by the Dean during a phone call to Myron Goldsmith: my temporary lack of aplomb had gone unre-corded.

The drive through the seemingly endless suburbs of Chicago, our belongings in a U-Haul trailer, was quite an eye-opener: very different from our leafy near north neigh-bourhood close by the lakefront. Arriving in St Louis, we thought to have a picnic on the bank of the Mississippi; but the smell put an end to that idea.

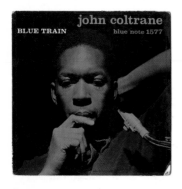

Opposite page: 'Blue train' mon-tage: a view of East St Louis and a woman digging for dropped coals by the Illinois Central Railroad

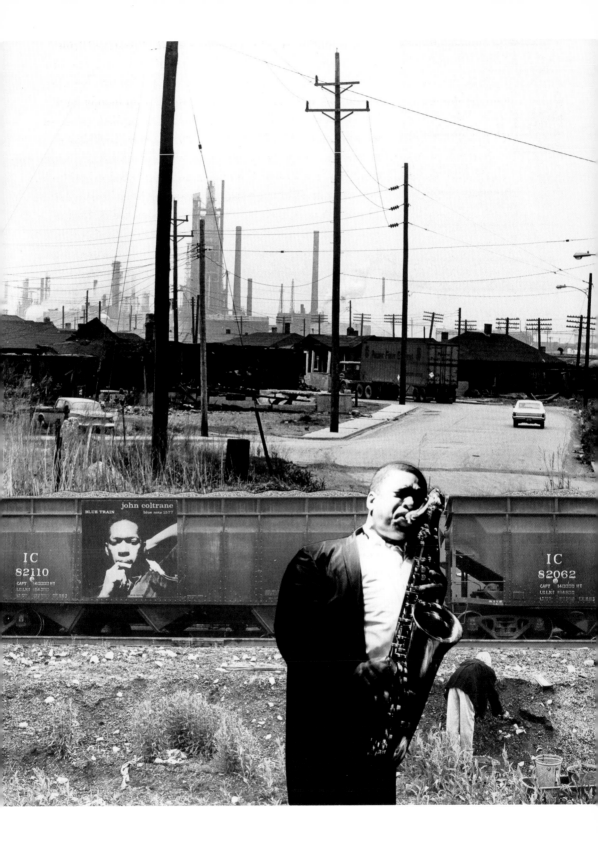

St Louis

BOY RUNNING FROM STOLEN AUTO IS SHOT

Wounded Seriously by Detective — Companions Caught

A 13-year-old St. Louis boy was wounded seriously last night when shot as he and two companions jumped out of a stolen automobile and ran at Wesgate and Enright avenues in University City.

Detective James Boevingloh, one of three plainclothes officers assigned to the Eastgate-Wesgate area in unmarked patrol cars, shot the boy as he ran across a field. The boy was taken to St. Louis County Hospital. One of his companions was arrested 15 minutes later and the other about 5 a.m. today.

Boevingloh said he had parked at the intersection and saw the three in the car. It fit the description of one that had been reported stolen.

The boys slowed as though to stop, but instead hopped out of the still-rolling vehicle on the passenger side. When Boevingloh turned on the lights of his car, they started running. The car they were in went over the curb and came to a halt against an apartment building at 714 Westgate.

Two of the boys ran down an alley and the third ran through a vacant lot. Boevingloh said that he called for the third boy to halt and fired one shot into the air. When he did not stop, the officer fired a second shot from about 70 feet. The bullet entered the boy's back, ranged upward to his lungs and emerged from his chest.

The second boy was arrested when he attempted to climb a fence on Vernon avenue. The third was seen walking in Enright and was arrested. All three are known as juvenile offenders, police said.

In 1904 St Louis had been the home of the Louisiana Purchase Exposition, marking the centenary of that early triumph of capitalism. It became known as the St Louis World's Fair and was celebrated in the nostalgic film *Meet me in St Louis*. One of the very few permanent buildings left was now Brookings Hall, the defining landmark on the university campus. The massive Exposition was, by now, notorious for its 'human zoo', which had featured African pygmies. One of these men, Ota Benga, was later exhibited in a cage at the Bronx Zoo in New York, together with an orangutan, before ending his days in Lynchburg. The legendary Geronimo was also on show, complete with tepee.

Now only a fragment of old St Louis remained. Titled 'Gaslight Square', it was a Disneyfied enclave with the mandatory gift shops. Gone were the trolleys, only 'The trolley song' remaining – and now part of the jazz repertoire. A more recent monument to the same era was the Jefferson Memorial Arch, a massive stainless steel structure spanning over two hundred metres, designed by Eero Saarinen, who, following his father, had left the lakes and forests of Finland for the bright metallic world of the automobile. Surrounded by desolation – it was here that I photographed Snooks abandoned liquor store – the arch appeared as a gigantic gateway to nowhere in particular.

Another type of enclave was the 'gated community' with its own guardians. One of these boasted the sign 'Sentinel security – armed response'. The stockade mentality of the Wild West continued into the present. The university campus, too, had its own police force, keeping a special eye on student activists; it was 'suspected of fully co-operating with the FBI'.

We had been provided with an apartment just a short walk away from the campus. Shortly after moving in we were woken in the early hours by an almighty crash, followed by gunshots. I looked out of the window in time to see two men dragging a spreadeagled black youth into a car. We were even more disturbed to read the newspaper report the following day. It was a brutal introduction to the summary

68

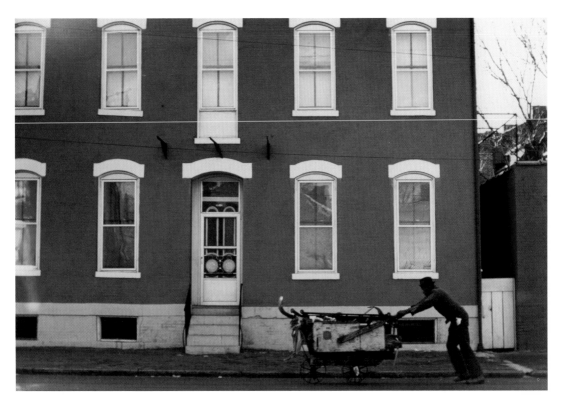

justice of a trigger-happy culture, which, if the statistics were to be believed, made America the gunshot capital of the world.

When I was asked at the rental office how we were settling in, I mentioned the incident. 'Oh yes,' the clerk replied, 'we get a lot of trouble with the black kids here.'

I was drafted into the third year studio with an admirable local architect, Bernard Bortnick. The projects he set were socially motivated and based on real needs in the community. I took an immediate liking to him and we got along fine. His steadfast character came to remind me of Boxer in George Orwell's *Animal Farm*.

I had to be in the studio on afternoons only, which left the mornings free for photographing. There was one day when I was picked up by the police and spent an uncomfortable moment in a basement holding area. The left-hand drive to the patrol car allowed space for an impressive shotgun rack. The first question when stopped was always 'where's your car?' – the idea of walking around was itself suspicious. A meeting with George Talbot, the editor of

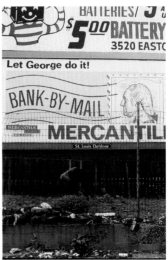

Top: a gentrified area of St Louis

Above: urban gardening under the sheltering hoarding

Overleaf: construction site close by the new arch

69

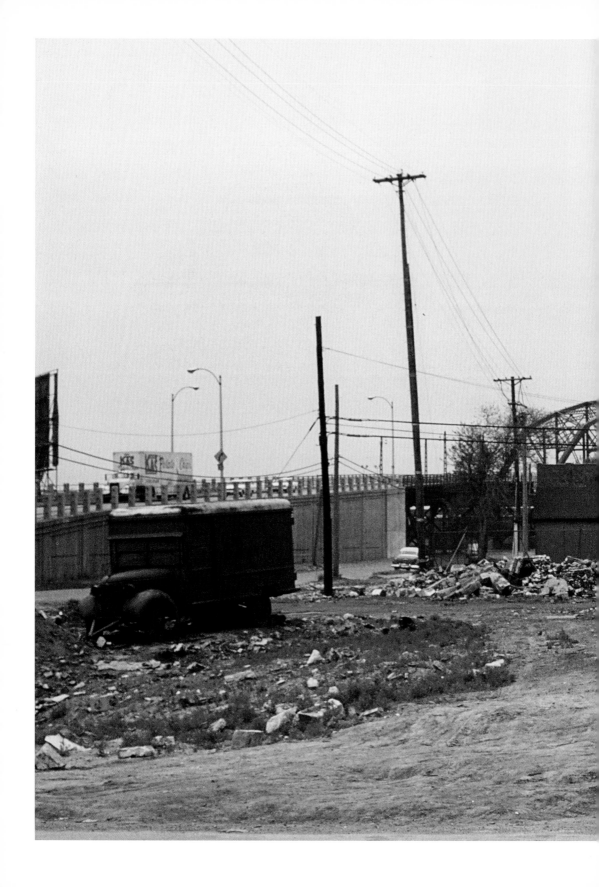

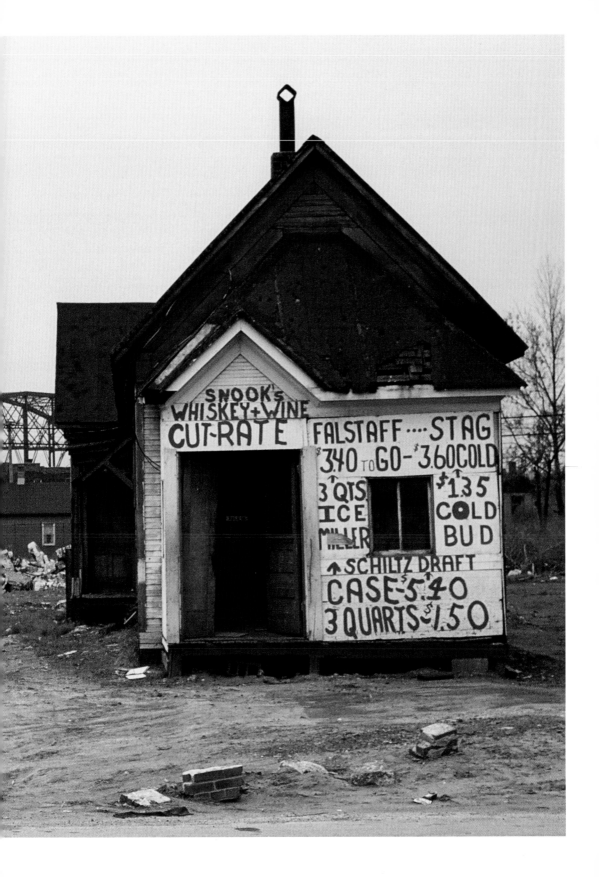

The contrast between advertising and reality becomes a cliché

a radical sociology magazine *Transaction*, published on campus, provided an outlet for some pictures. One taken on Maxwell Street in Chicago he enthused over for showing 'so many different types of poor people'.

I soon became firm friends with another Londoner teaching there, artist and graphic designer John Wallington – a jazz fan – and with the artist Oliver Jackson, who took me under his wing for trips to clubs in East St Louis, as part of my education. On a trip to downtown St Louis – actually there wasn't any downtown – I photographed an immaculate accordion player outside Walgreens store: surely the best-dressed musician of the blues world. Down by the river, an image of the bridge with the bus leaving St Louis prompted the reminder that this was where Miles Davis started out, and where he returned home to finally lose his drug habit. He told the story that his father would never cross this bridge, as he knew of the dubious contractor who built it.

The architecture studios were next to the artists', so there was a healthy social interchange. We spent one evening with an unusual Ruskinian couple, who served dinner by candlelight on an empty cable drum: they had cut off the electricity and furnished the house from skips. Another couple from Finland, with whom we became longer-term friends, designed and made their own clothes in the manner of the Russian constructivist Alexander Rodchenko.

The architecture school invited many international figures to lecture, including Jacob Bakema from the Netherlands and other members of the CIAM Team Ten group: this was no provincial backwater. It was here that I first heard Allen Ginsberg in person, as poet in residence. The university presence did also help the survival of one independent cinema showing foreign films. We saw Godard's *Alphaville* there, which Bernard Bortnick said could have been St Louis, and Antonioni's *Blow-up*, with soundtrack by Herbie Hancock.

Mark started primary school in St Louis, and Heinke found a job as secretary to Ed Bloch, who had a bookstore on the edge of campus.

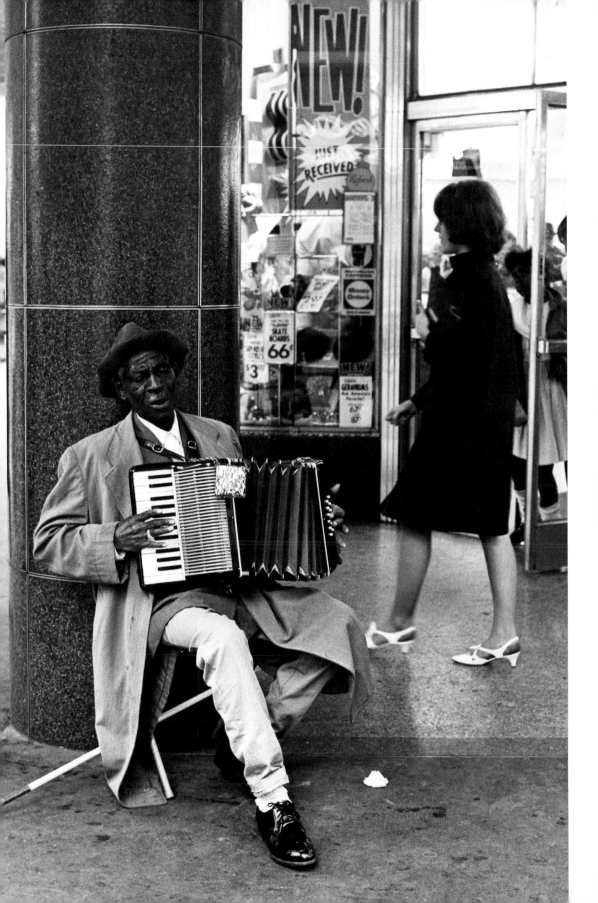

As a visitor, I was called on to give a lecture to the whole school. It was even advertised on the local radio station. The subject was Holland, still inspired by a visit there, which much later became the starting point for the book *Fragments of utopia*. Unfortunately my interest was shared by another faculty member. I prepared a tape recording to go with the slides. Some friends, seeing I was nervous, gave me a joint to help me relax. Confidence and excitement at the full house slipped into paranoia as the slides went haywire. One even came up saying 'trick or treat?' – it was around Halloween. Somehow I managed to stammer through, helped by the tape. Immediately afterwards, Bernard came up to me to say that Oscar Newman had been looking through the slides in our office. Next day, I went to his studio to challenge him about this 'prank'. 'How dare you come into my studio!', he shouted, hurling a flower pot at my head. He later gained kudos as the author of a textbook, *Defensible space*.

Jewson Bros. Market, with the Church of Christ above

We started to miss Chicago and returned there for Christmas, staying with Declan and his family. New Year's Eve was spent in the Plugged Nickel: this time with the Horace Silver Quintet playing in the new year with the great 'Song for my father'. He had had an earlier hit with 'The preacher', so I combined a photograph from that evening with linked images from St Louis, including the 'jack-leg' preacher.

Opposite page: 'The preacher' montage: St Louis and outskirts

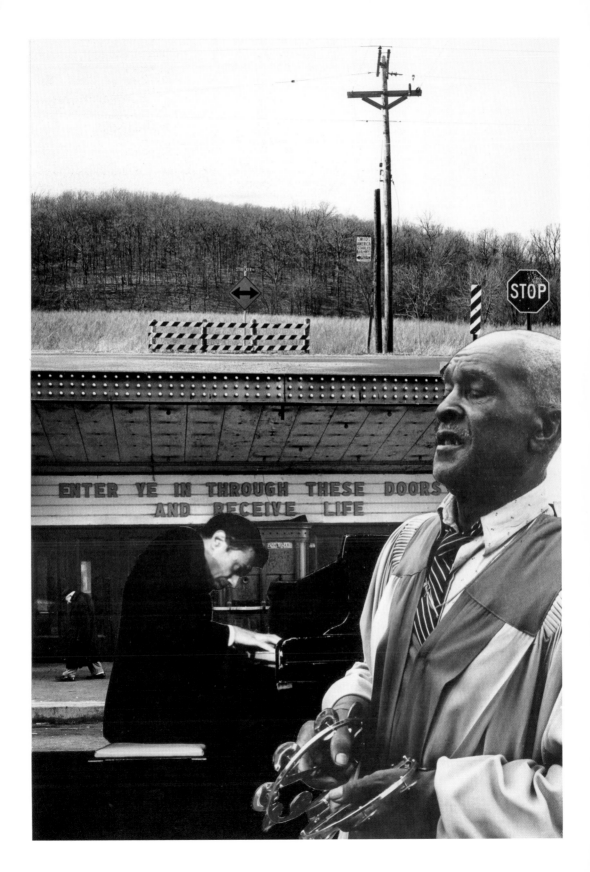

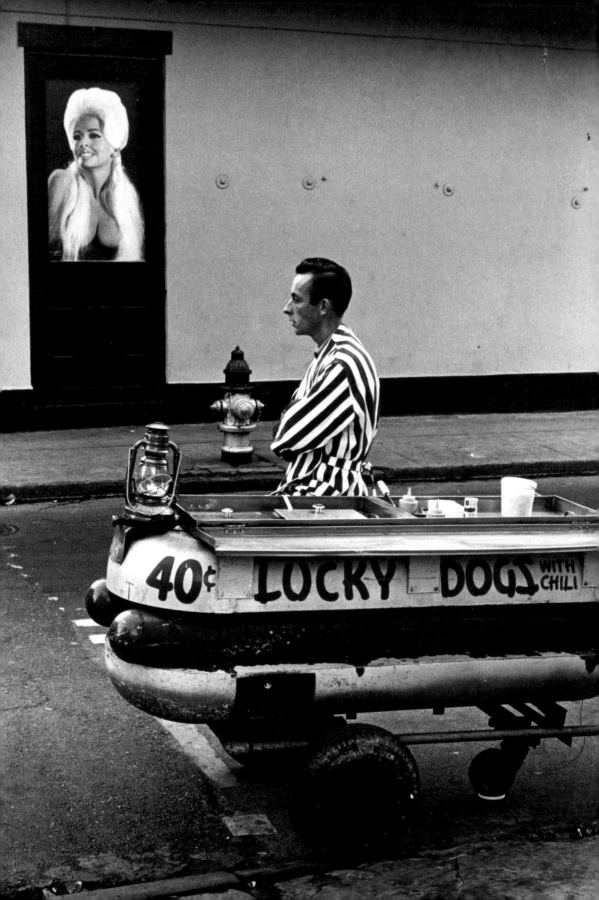

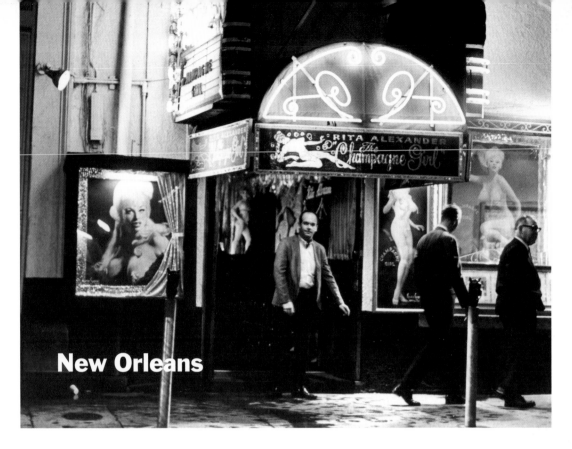

New Orleans

John Wallington and I had decided to make a short trip to
New Orleans, for Mardi Gras. To save on accommodation
we took an overnight bus. At a comfort stop in Jackson,
a Southern redneck was whining about the Civil Rights
Movement: 'It's the Commies behind all this nigger crap.'
Arriving early, we found a room in the Old Quarter, where
I could photograph from the balcony. After dark, an atmo-
sphere of turpitude hovered over the clubs and gift shops.
Perhaps not as bad as Ignatius J. Reilly's 'flagrant vice
capital of the civilized world', in John Kennedy Toole's New
Orleans masterpiece *A confederacy of dunces*, written at
this time, but not published until 1980, a decade after the
author's early death.

We went instead to Preservation Hall to hear some
authentic jazz. The all-white audience seemed happy at the
memory of the 'good old days', slapping their Bermuda-
short-clad thighs. We couldn't share the enthusiasm, and
when the Ink Spots put in a guest appearance with a 1940s
ballad, 'Red roses for a blue lady', we left.

Portrait of John Wallington, influ-
enced by Art Kane's mirror photo of
Lester Young

This page: Saturday night and
(overleaf) Sunday morning

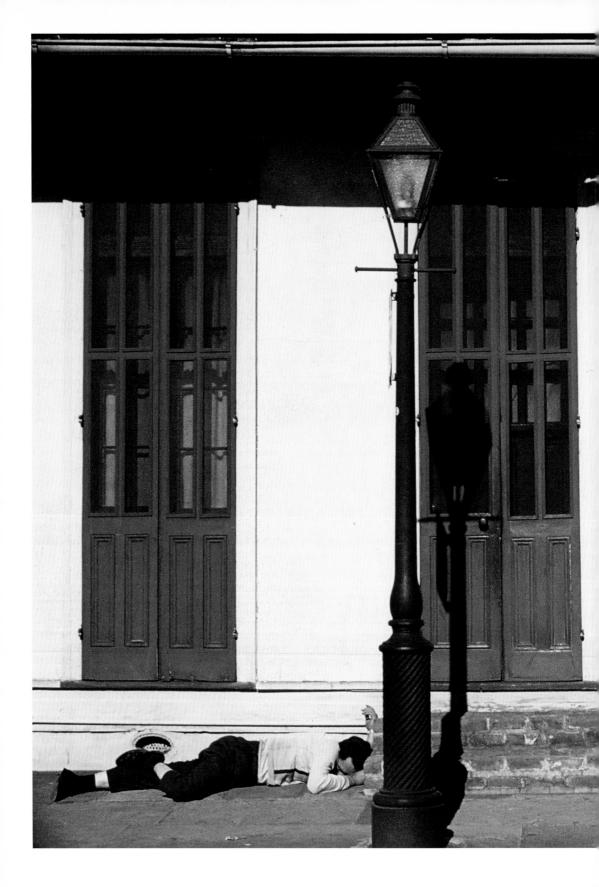

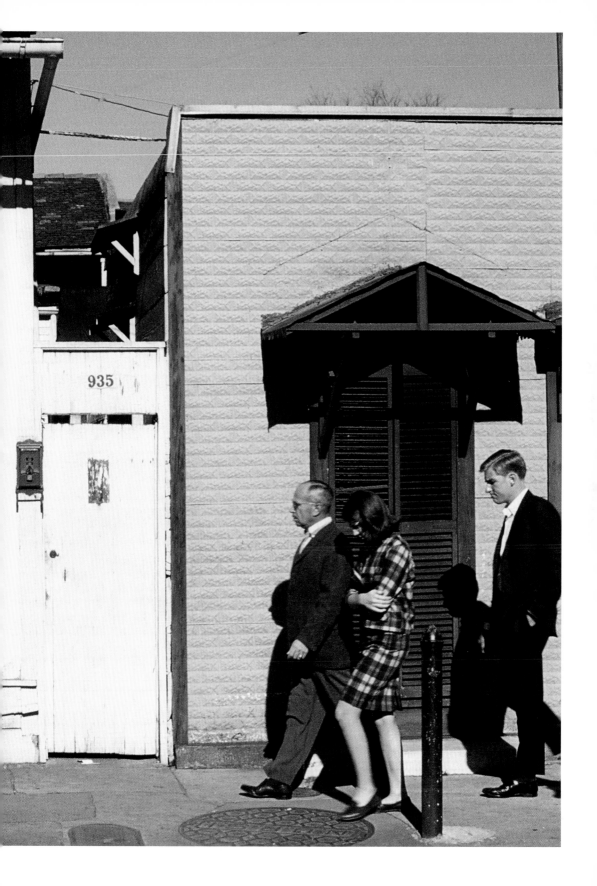

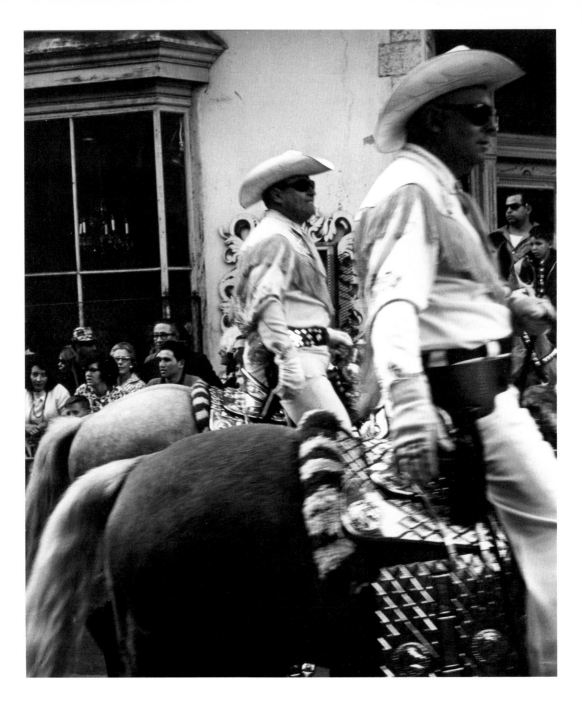

Seeing John and myself armed with cameras, a passer-
by directed us to the scene outside the Royal Castle diner:
'There's a guy lying there with blood all over his head, and
tatooed arms – it would make a great photo.' We did hesi-
tate for a moment.

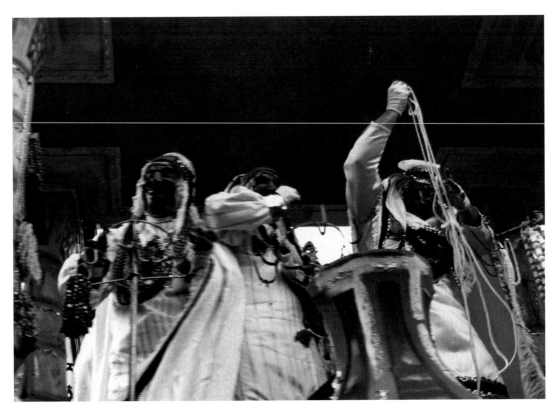

Masked figures throwing plastic beads to the locals.

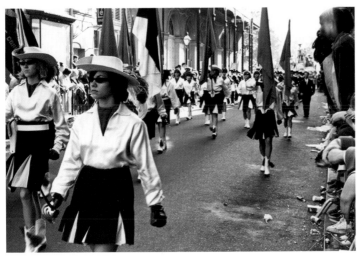

The Mardi Gras parade proved another disappointment. We had hoped for a classic marching band in the New Orleans style, not the slightly sinister parade of masked figures, cheerleaders, local sheriffs, and the National Guard. We decided to head back to St Louis the next day.

Overleaf: fit for a king?

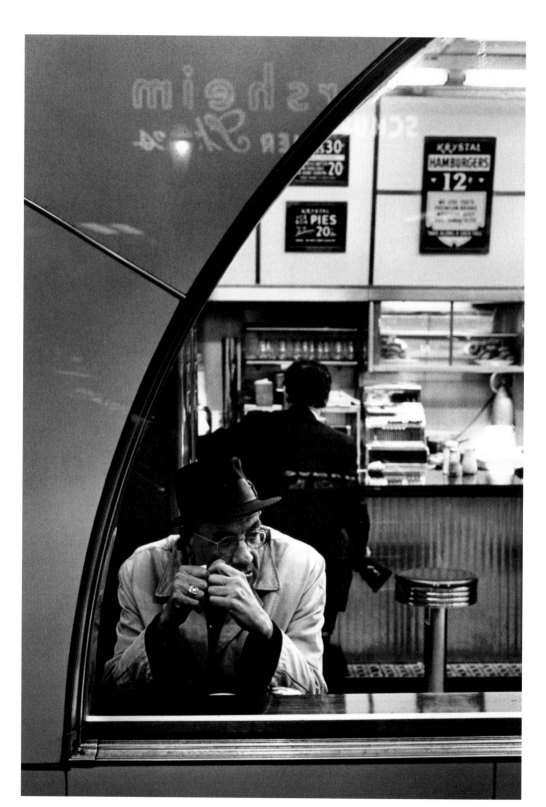

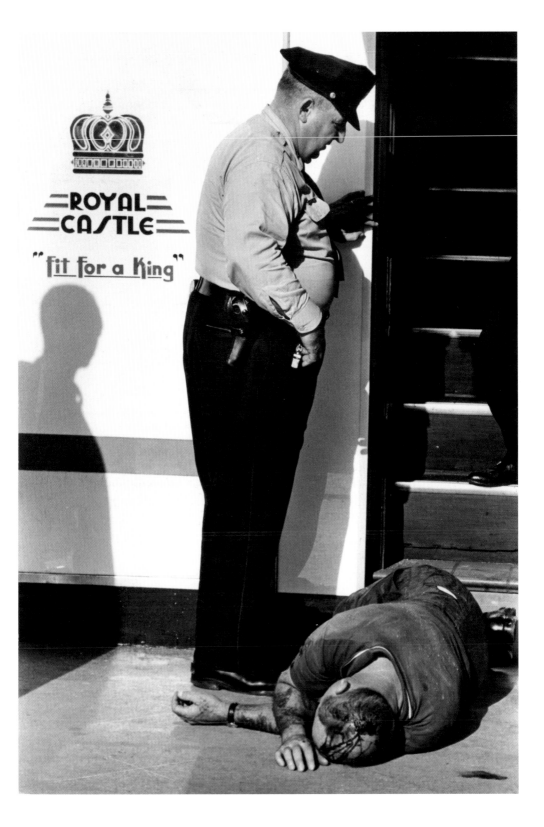

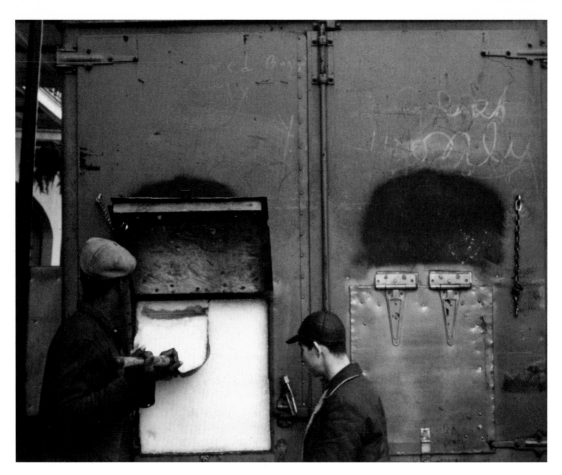

A hint of Mark Rothko in the paint-work to this ice wagon. The graffiti reads 'colored boys only', but the driver is white

For some reason we had to change buses in Baton Rouge, where Ornette Coleman had been beaten up for a solo some patrons had taken exception to. In the cafeteria, we didn't have enough money, and had to put something back. John became nervous as he watched someone go to the phone while staring at us. I had a moment of fright when someone crept into the toilet, following to spy on me – there were no doors on the cubicles. We were mightily relieved to get on the bus, which was packed. John had to sit behind me. A short while later, the bus suddenly stopped in desolate surroundings. An unmarked car was alongside, parked on the bank of a levee. A very large man got on board and, after a quick word with the driver, strode up the aisle and slapped me on the shoulder: 'Where's your ID?' he demanded. Trembling with fear, I showed it. 'Where's your partner?' (How did he know I had a partner?) John had to

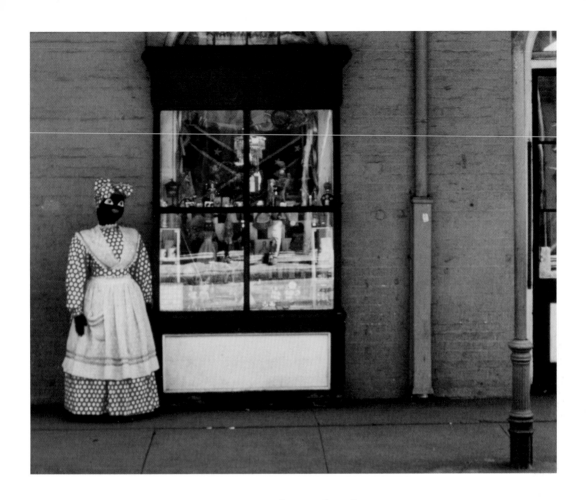

get up to reach the luggage rack; as I turned I saw the other man outside holding a gun to the window. There was a silence. I managed to say we were teachers from the university, just down for Mardi Gras. He said nothing, just got off. A hubub of conversation broke out: 'You're from England! What do you think of that ...' Saved again. Colleagues had warned me to get a shave and haircut if going south, but I had paid this no heed.

No longer the clean-cut SOM employee. (Photo: St Louis Post Despatch)

Overleaf: travelling through the night on the Greyhound bus had the ominous feeling of Elvin Jones's drumming on 'Alabama'

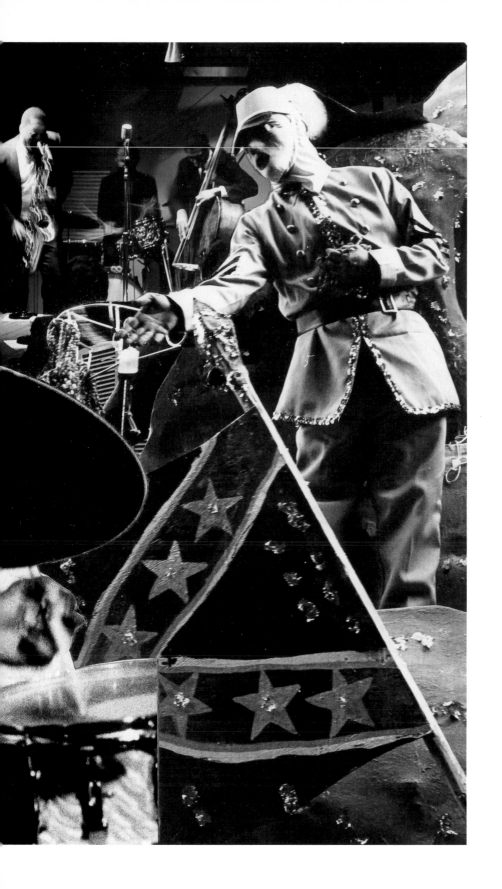

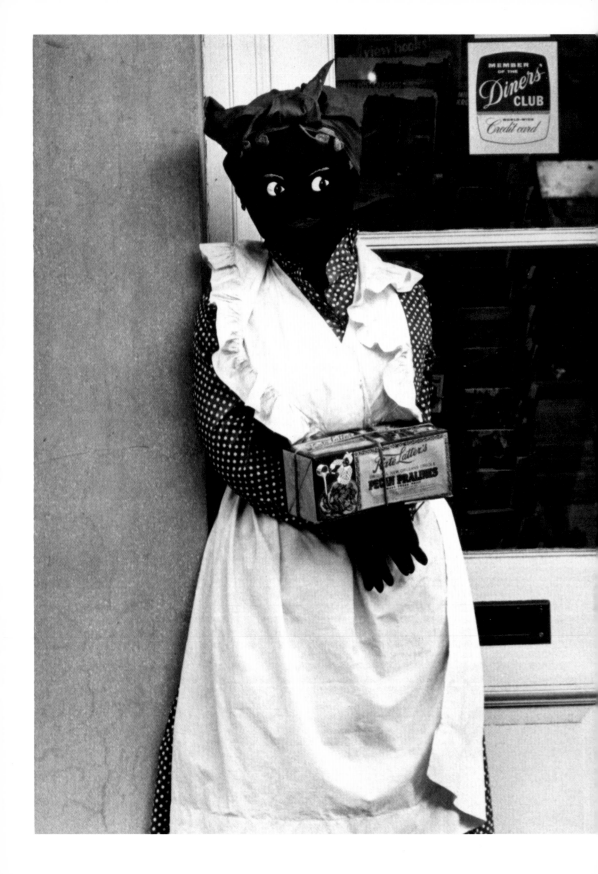

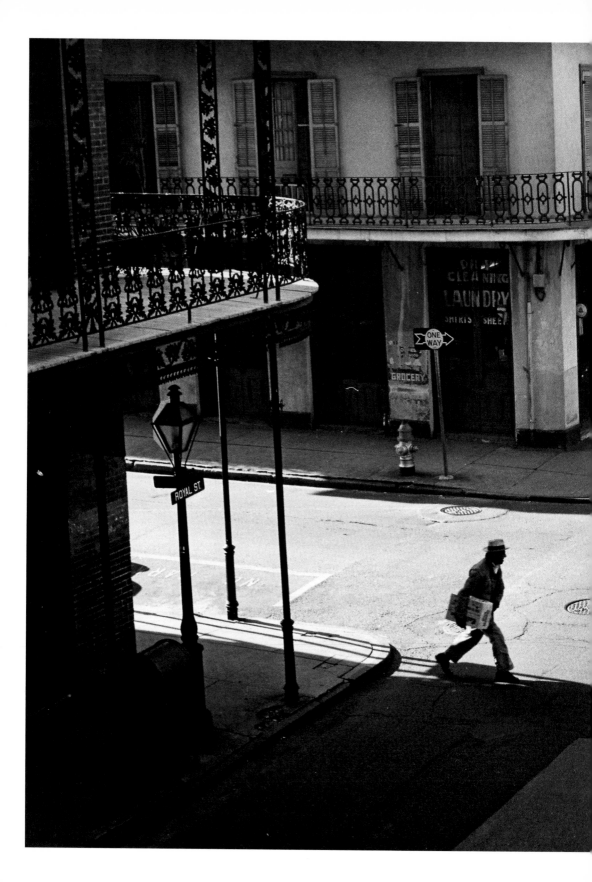

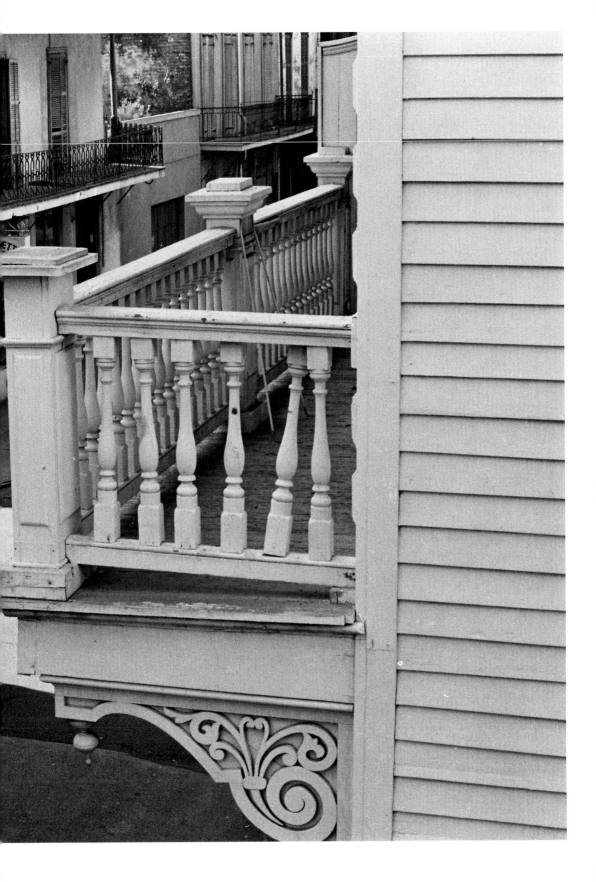

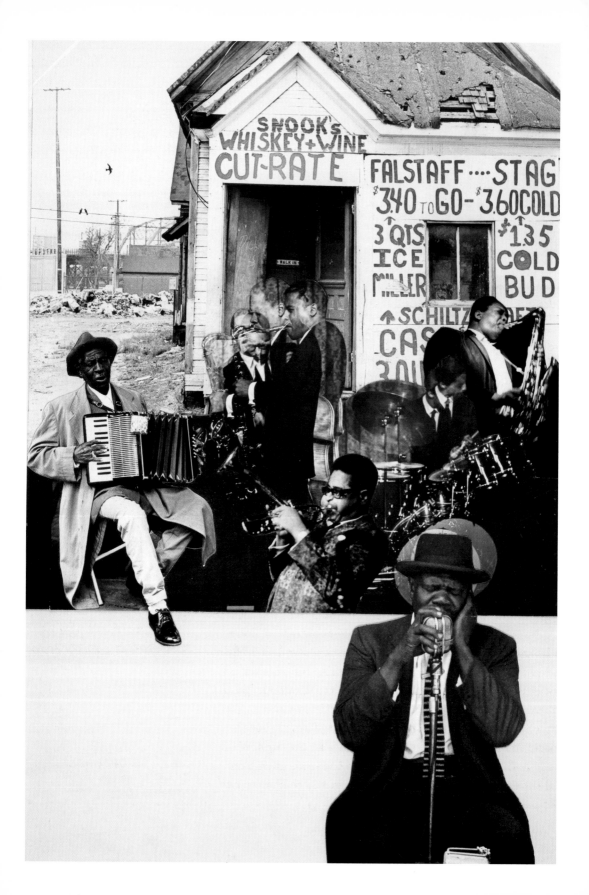

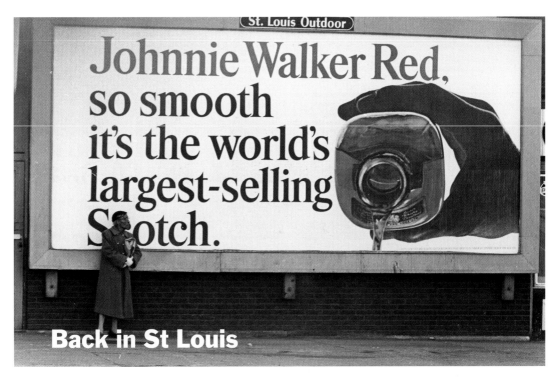

Back in St Louis

The escalating war in Vietnam was becoming a big issue with students on campus and I decided to join a protest march (which the was to be the first of many for me). I was amazed to see the commanding figure of Bernard Bortnick, handing out leaflets for the Socialist Labor Party of America, a lone presence from the architecture faculty. He was certainly very interested in the book on the radical architect and ex-Bauhaus teacher Hannes Meyer that I had bought in Chicago, but I had no idea that he belonged to a political party. The socially engaged projects that he set for our students would not have been unusual back in London.

Around the time of the anti-war demonstration, John Wallington and I were coming back to the campus when an open-top car drove past, full of neo-Nazis, one even with a swastika armband. John's mistake was to shout out 'fascist bastards'. The car spun round in a fast U-turn and two of them leapt out – one with a baseball bat. They chased us right up to the faculty building, gaining all the time. We only just made it. It might have been the same gang that later fire-bombed Ed Bloch's bookshop, where Heinke had worked.

Opposite page: this montage was done for John Jeremy's TCB Releasing jazz and blues film company, and was screen-printed on silver paper

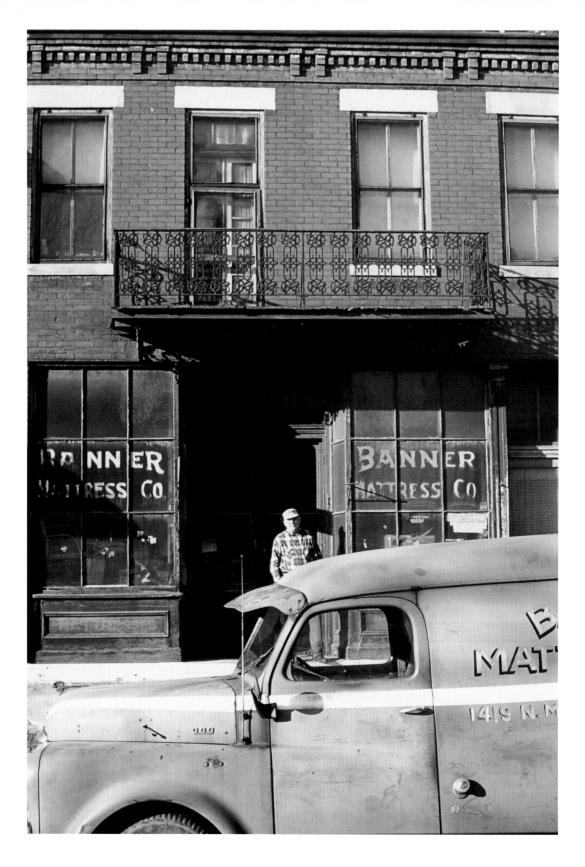

In St Louis there was nothing like the range of jazz enjoyed in Chicago, so I got in touch with Roscoe Mitchell, with the idea of inviting him to the university; we could have the venue free and pay the musicians what we raised from ticket sales. He agreed to bring what was, in effect, the nascent Art Ensemble of Chicago, with Lester Bowie, Joseph Jarman, Malachai Favours, and Philip Wilson. John Wallington set about designing and printing posters and tickets in the art school. Their brilliant green soon provided an inviting splash of colour around the campus and town, and we even got some air time on local radio. The group arrived a day early, in Lester Bowie's green Bentley, to check out the space and rehearse. Quite a stir ensued as Roscoe, Joseph, and Philip came looking for me in the architecture studio – and ticket sales took off. We had not known when fixing the date that Simon and Garfunkel were playing in the university auditorium the same evening, but we had

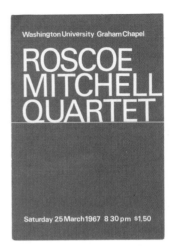

Ticket for the concert

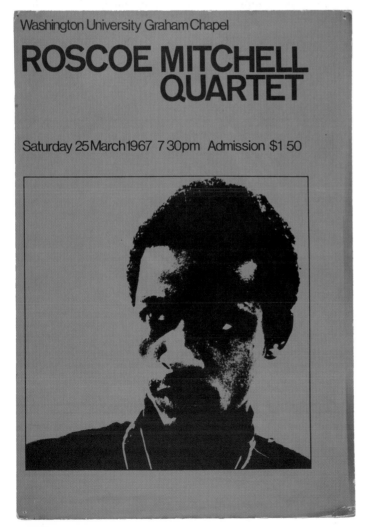

John Wallington's screen-printed poster based on the Sound *cover-photo of Roscoe by Billy Abernathy*

Opposite page: some parts of St Louis appeared unchanged since the Depression

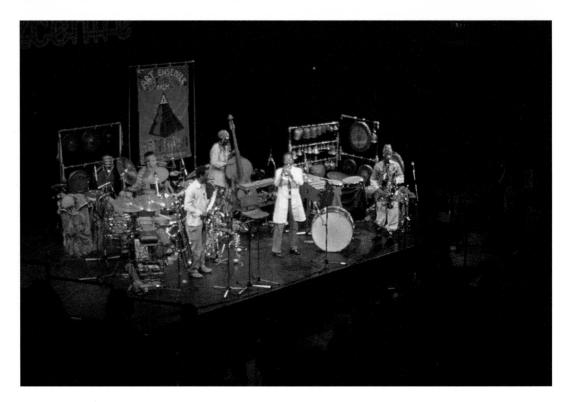

The Art Ensemble photographed later at the Roundhouse, London

Roscoe's cover painting

a full house anyway. The concert was a great success: one continuous performance taking in a history of jazz styles, with added elements of pantomime. Roscoe was a little disappointed that I didn't take any photographs. I had taken the camera, but was totally focused on the concert itself. I had already noticed that the concentration on photographing could spoil the enjoyment of listening, and so would alternate between the two. The group at this time still dressed fairly normally; later they began to resemble the painting that Roscoe did for their second album, under Lester Bowie's name. Lester, however, would play wearing a white lab coat, to emphasize his sound experiments. It was Lester Bowie who also sought to distance the group from the negative associations of 'jazz', with the banner proclaiming 'Great Black Music'. The following evening they put on another concert, this time scaled down to suit the much smaller space of a local coffee shop and book store: a chamber performance demonstrating their studied musicality.

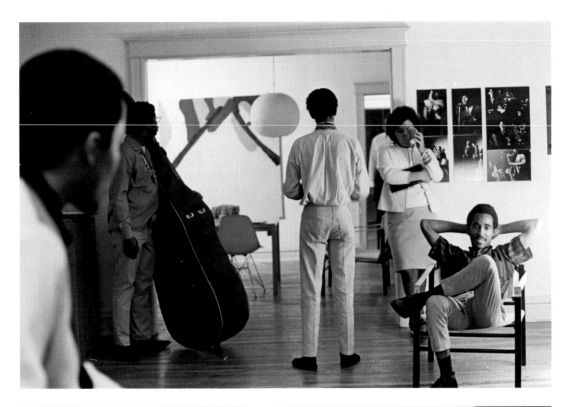

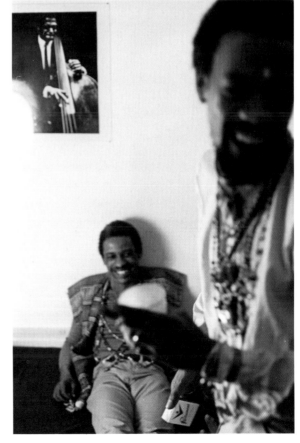

Top: Relaxing after the concert.
Malachi Favors and Joseph Jar-
man are looking at John Walling-
ton's painting 'Ornette' – a burst of
primary colours

Above: Miles Hopper and Joseph
Jarman

Right: Roscoe (seated) and Joseph,
with his third eye

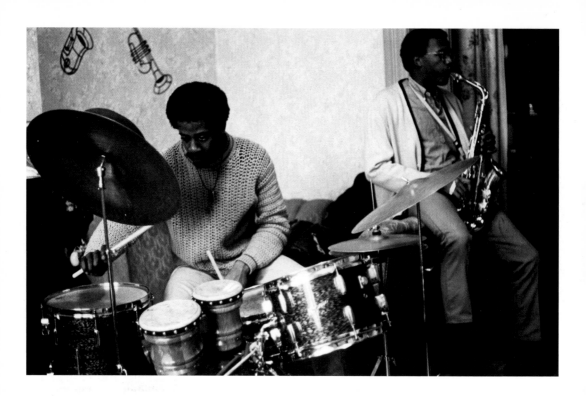

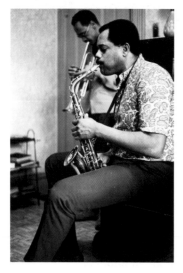

Top: Philip Wilson and Oliver Lake

Above: Julius Hemphill

Opposite page: montage; this was the view from the first floor window

Overleaf: 'Rivers of open space', including an electricity substation

Philip Wilson, the drummer, was from St Louis, and stayed behind to play with some local musicians including Oliver Lake and Julius Hemphill, whom I had never heard before. Thanks to Oliver Jackson I was invited to an informal session in a first floor room just a block away from the infamous Pruitt-Igoe housing project designed by Minoru Yamasaki, who had by now moved on to what was called the 'new beautifulism' of filigree facades, first used for the American Concrete Institute in Detroit (and, later, for the doomed World Trade Centre). A photograph from the window of this building was later used as part of a photo essay I had made on this project, thanks to Bob Harris, a project manager there and jazz friend. This was used in a sociology textbook, which disingenuously asserted that the old streets of houses did not provide enough room for all the southern immigrants – this in the wide-open spaces of the Midwest. It was later pointed out to me that the old pattern allowed for local enterprises and even smallholdings – all to be replaced by the ubiquitous supermarket. Hailed at the time for its 'rivers of open space', between what for all the world looked like a line of brick and concrete prison ships, Pruitt-Igoe was demolished in its entirety in 1972.

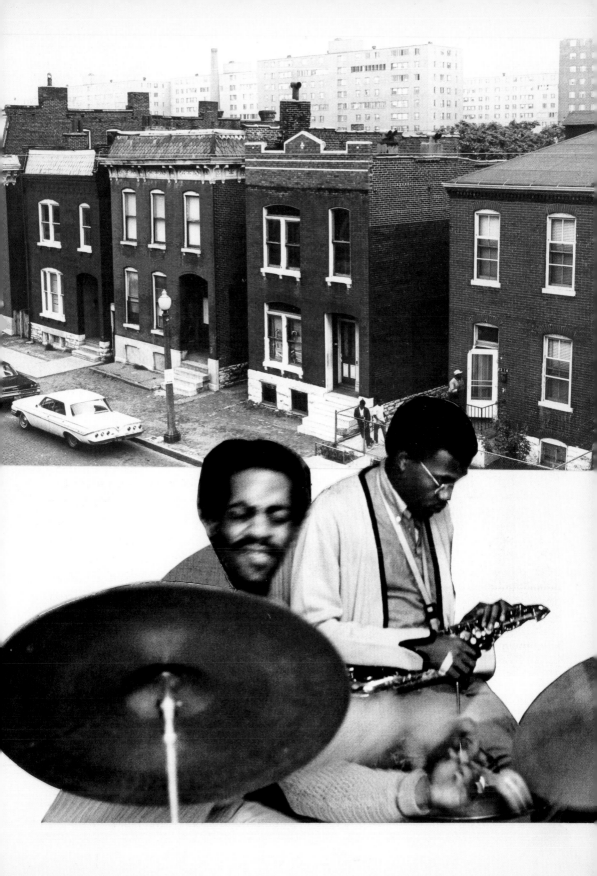

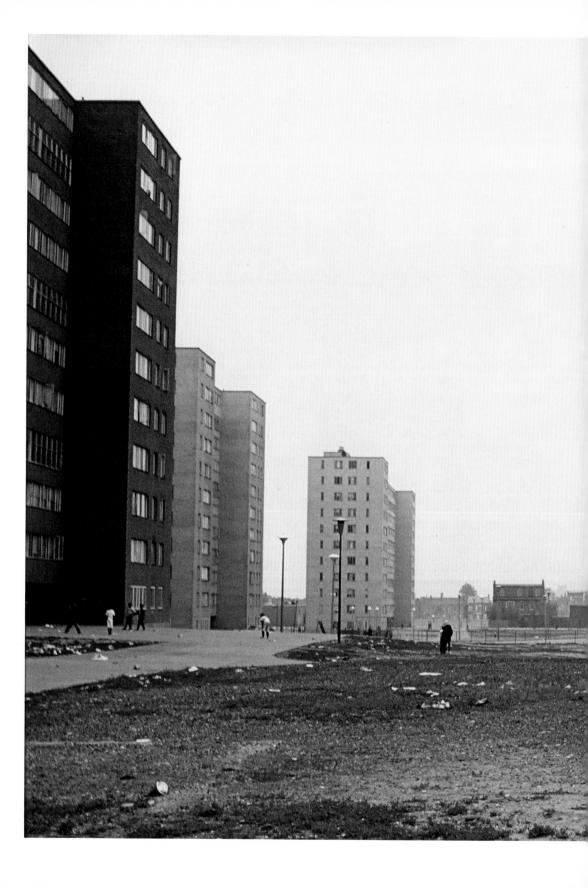

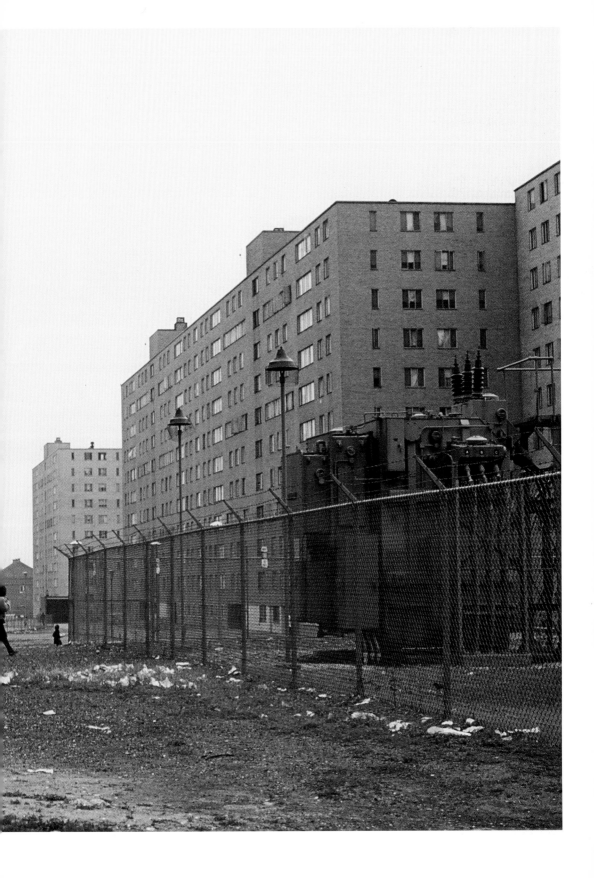

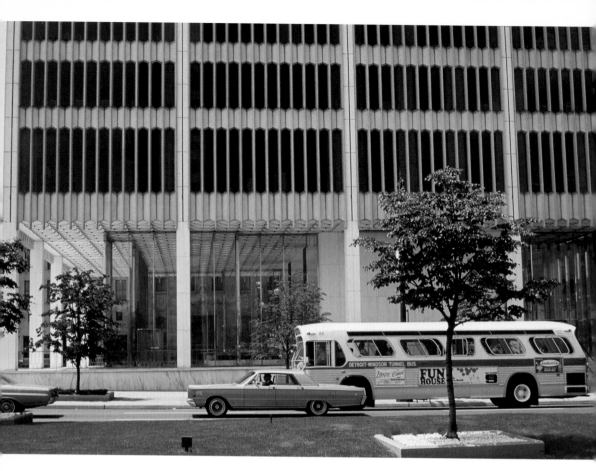

flag bags

NLF bags, red, blue & yellow, size 17" x 11½" x 5½"
Carry you message to and from the shop floor
2s each + 6d postage
10 or more post free
Get your and help the NLF
Cash with orders to Wild Enterprises 20 Chalcot Rd NW1

Top: Yamasaki's 'new beautifulism' in Detroit

Above: flagbag advertisement from Black Dwarf, *London 1968*

The request for these photographs came when I was back in England. I wrapped them up in a Vietnam flagbag, and included a couple of polemical quotations. They were returned with the reply: 'Don Quixote is alive and well and living in Chicago'.

Oliver Jackson asked me to photograph his exhibition: this would be my last assignment in St Louis. The disturbing, fragmented images seemed to me a painterly response to the Billie Holiday song 'Strange fruit', while the dangling feet seen above his portrait could refer to the recent, closing track on the great Archie Shepp album *Four for Trane*: 'Rufus' ('Swung, his face at last to the wind, then his neck snapped.'). It was Jackson, the sole non-white faculty member, who told me that if you truly listened to Charlie Parker, you would cry.

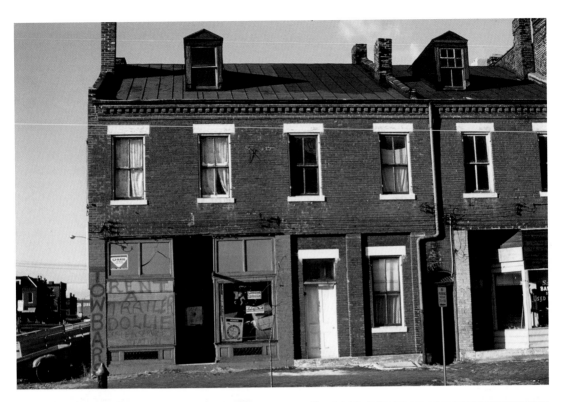

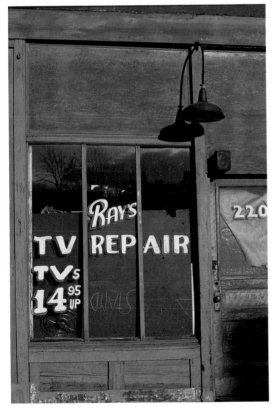

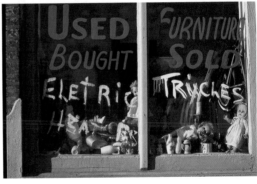

Local enterprises fitted into the familiar fabric of street-front houses, the loss of which formed the context of Jane Jacobs's The death and life of great American cities *(1961)*

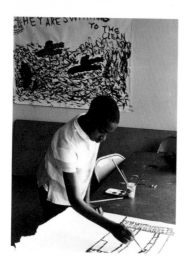

Above: Pruitt-Igoe, and one of
the projects referred to in Vincent
Terrell's letter (right). Their efforts
were in vain: the entire project was
demolished in 1972. The painterly
skills of the kids involved in this
clean-up campaign for Pruitt-Igoe
were amazing – especially the scene
that had begun with the lettering
and a line for the street, before
being filled in. Back in London,
photographing the Economist
building, I saw a similar figure
cleaning the street

August 17, 1967

Mr. David Wild
20 Chalcot Road
London, N.W.I.

Dear David:

This is the first time I've truthfully had a chance to write.
I was planning to leave for London in September, but plans
have changed. Right now it is undecided -- maybe next spring.

You know that Bobby, Oliver and I are working at Pruitt-Igoe.
The program is getting more and more intense, and there's
a possibility of a regular job -- if the city comes across
with some money. "The seeds are kind of thick on the surface
of the project streets." I'm trying to put on a play with the
kids -- it's pretty hard to get them organized, as you can
imagine! Another thing I'm doing is taking two or three of
them out a couple of times a week -- to the arch, the museum,
just hanging out. This I find very gratifying.

I was in Chicago a few weeks ago and witnessed one of the
most dazzling events of the year -- Roscoe Mitchell and
Joseph Jarmin, both leading their own groups in concert at
the University of Chicago. Philip Wilson, the drummer (I
know you remember him) is playing washtub and washboard,
and an electronic sounding device along with his drums.
It's really something. Since then, he's left Roscoe Mitchell
and joined the Paul Butterfield Blues Band in San Francisco.
Archie Shepp has a new album -- Mama Too Tight. It's pretty
nice!

I must go now. Regards to Henneka and Mark, and I hope
you'll write if you have time.

Vincent Terrell

Opposite page: Oliver Jackson at
the opening of his exhibition

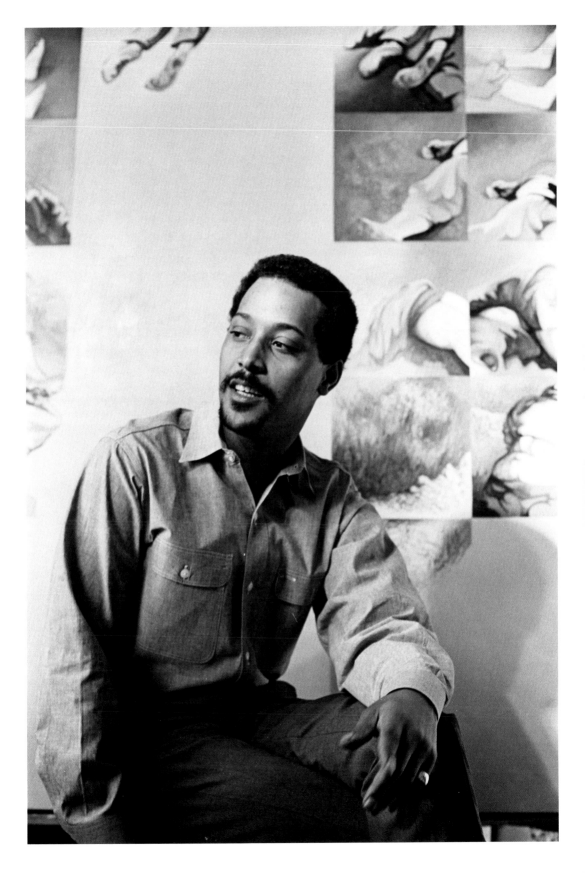

Shortly before we left St Louis, John Wallington found a new girlfriend, who was working as a waitress in a local diner. I was given an excited description of her attributes, in which the physical loomed large, and he said that she slept with a knife under her pillow. Later this would be used on him, after they had moved to New York. John told a story that one morning he was walking her dog when an elderly black woman in front quickly left the sidewalk. 'It's all right,' John said, 'he doesn't bite.' With a look of incredulity, the woman replied: 'He's got teeth, ain't he?'

More than a year later, when a deeply scarred John returned to London, he told me that the only time I had called on them with Bob Harris, John's girlfriend had claimed to recognize him from her days as a typist for Pinkerton's Detective Agency, before he left to join the FBI. I had known Bob as a good friend who would sometimes come by, a little stoned, to listen to a favourite Coltrane record *Kulu se mama*, and share a puff with me. Having signed a declaration on my visa application that I was not entering the USA to engage in criminal activity or attempt to overthrow the government, this retrospective tale did not faze me.

My year of instruction was almost over. An offer from Peter Cook, back in London, of two days a week tutoring in the Diploma Year at the Architectural Association was enough to decide on a return home. On the way back we stopped in Chicago to say goodbye to Declan and friends; we listened to an afternoon rehearsal in Roscoe Mitchell's basement – a sort of farewell concert.

John Wallington's sister was living in New York, so we arranged a short stopover there for our final weekend in the USA. Most of our belongings had gone by sea, including a trunk full of precious jazz records: Atlantic, Blue Note, Prestige, Impulse, and all. The most extraordinary was Albert Ayler's *Bells* on the ESP label: a single-sided transparent disc, with a red screen-printed title on the reverse. Another frantic airport moment occurred as our taxi got stuck in the Sunday sightseers traffic. We had to run the last few hundred yards, clutching our luggage, or would have missed the flight.

Opposite: montage – Miles, Silver, and Tony Williams leaving Chicago

106

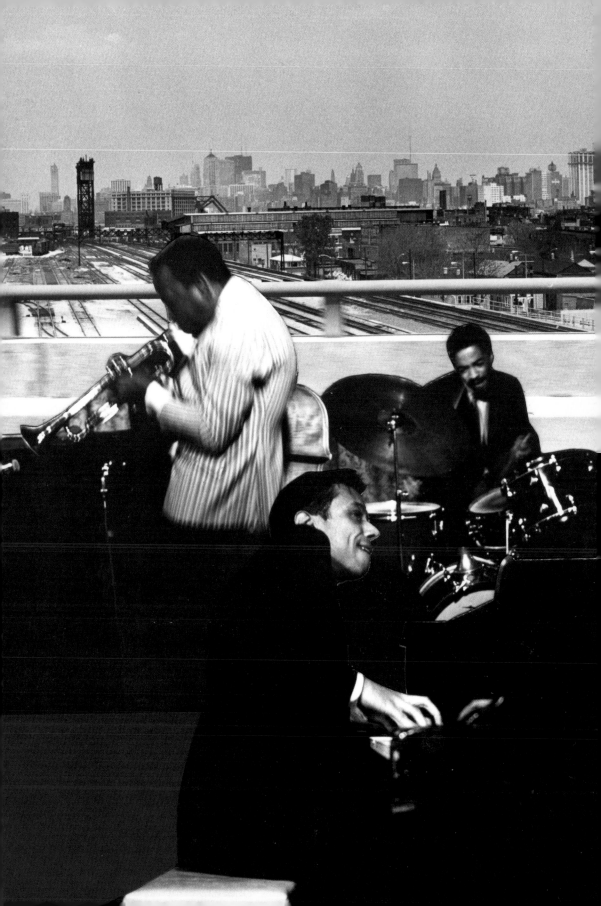

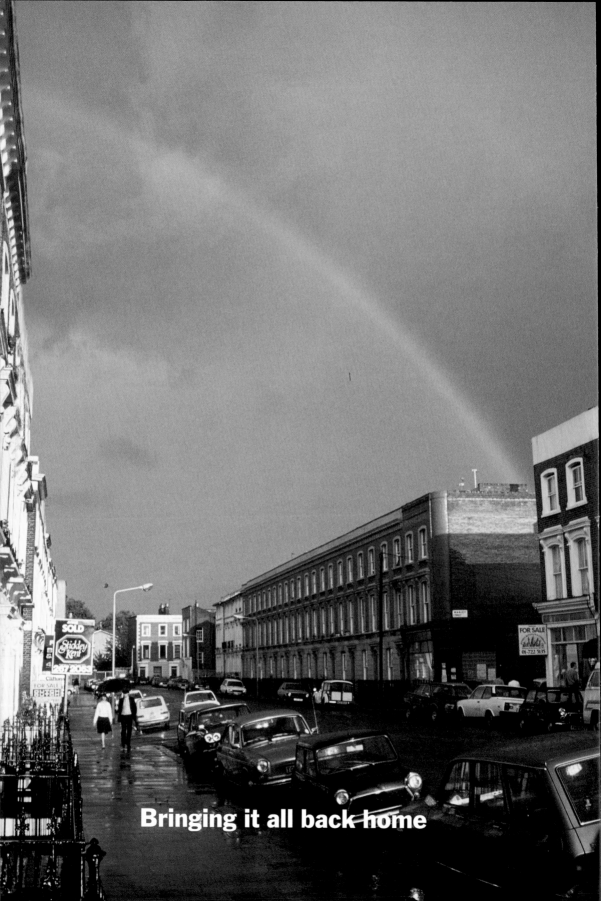

Bringing it all back home

A convoy of three little Minis, driven by friends, was at Heathrow Airport to take us home. We were back in dinky Britain, where all seemed ready to tune in to *Sgt. Pepper's Lonely Hearts Club Band*; but I was following a different drummer. Stepping back into our recently vacated flat, we found a police receipt for a Smith & Wesson handgun pinned to the kitchen table with a knife. The walls were hung with crudely executed psychedelic paintings. Venturing downstairs we found several wooden boxes full of large stones with holes through them, apparently sent from America. On the shelves were some animal skulls, and a human skeleton hung in one corner. Outside, in the basement area, was a long-playing record, seemingly thrown out of the window. It was Albert Ayler's *Ghosts*, on the Fontana label. Leo, the newsagent opposite, from whom our sub-tenant had bought her daily ration of Mars Bars, told us that she had created quite a stir with her habit of cleaning the street-level window topless, but was now in Friern Barnet Mental Hospital.

Another story could begin here, but that night I had a vivid dream. Back in that strangely golden light of the Detroit club where we had last heard John Coltrane, I was asking him how he found such power. 'It isn't easy', he replied. Next day I rang Peter Cook to say we were back. 'Have you heard?', he said, 'Coltrane has died.'

Opposite page and above: Chalcot Road

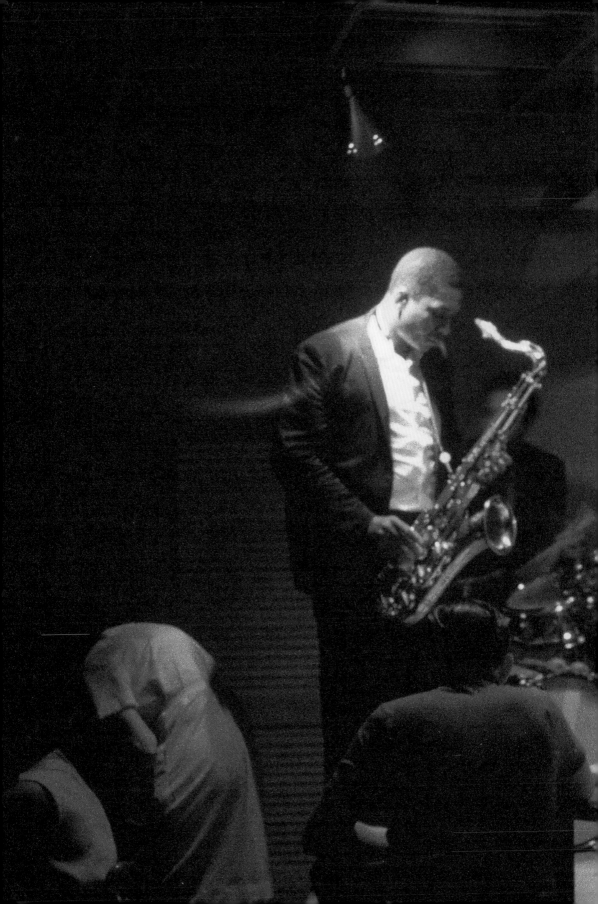